IRELAND'S WILD ATLANTIC WAY

Carsten Krieger

THE O'BRIEN PRESS
DUBLIN

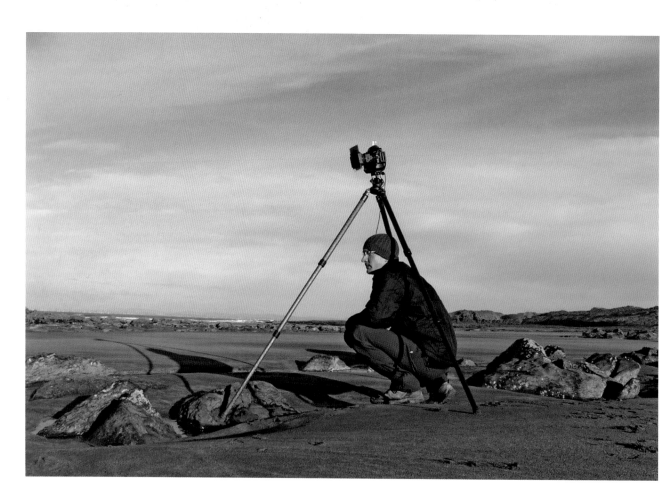

CARSTEN KRIEGER is a professional photographer based in the west of Ireland. His unique images of the Irish landscape are highly acclaimed and he is the author of five books of landscape and wildlife photography, including *Ireland: Glorious Landscapes*, *Beautiful Landscapes of Ireland* and *Ireland's Coast*. His photographs have been published in magazines and calendars and he also exhibits in Ireland and abroad on a regular basis.

CONTENTS

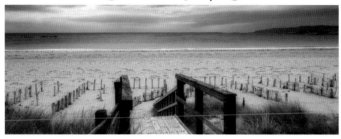

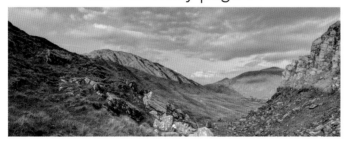

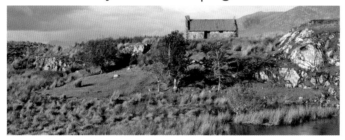

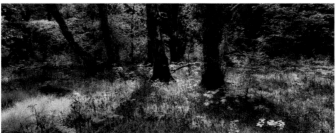

INTRODUCTION

The Wild Atlantic Way hasn't just appeared overnight. The 2,500 or so kilometres of coastal route along Ireland's western seaboard have always been there; all it lacked was a name. In 2014 the Irish Tourist Board changed this and officially launched the Wild Atlantic Way, a touring route from the Inishowen Peninsula in the north to the Old Head of Kinsale in the south … or the other way round if you prefer.

Along this route you will find many of the visual highlights Ireland has to offer: dramatic sea cliffs – among them the highest in Europe – seemingly endless sandy beaches, hidden coves, remote valleys, Ireland's highest mountains and oldest forests, as well as vast stretches of rare and squelchy bogland. Nestled in this natural landscape is Ireland's built heritage. The colourful towns and villages, ancient tombs, old abbeys and castles and the ubiquitous drystone walls fit neatly into the scenery and in many places are an integral part of it. Last, but not least, there are the people who carve out a living in this rough landscape.

Despite its immense beauty and rich heritage the west of Ireland is not an easy place to live and make a living: poor or waterlogged soil limits farming in many places, bad infrastructure leads to high unemployment in rural areas and over all of this hangs the unpredictable and often violent weather. But the people of the west are used to it: during Ireland's Great Famine of the 1840s, when 25 per cent of the population starved to death or was forced to emigrate, the west was hit hardest. The still-standing shells of abandoned villages are a stark reminder of this darkest part of Irish history. The west was also the last part of Ireland to get electricity: some remote areas, like the Black Valley in County Kerry, were only connected to the grid in the mid-1970s, over a decade after the rest of the country.

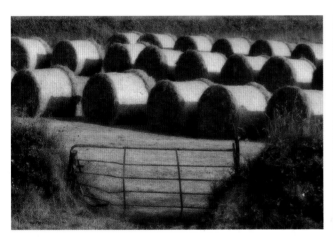

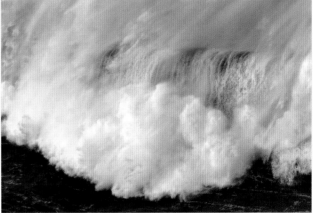

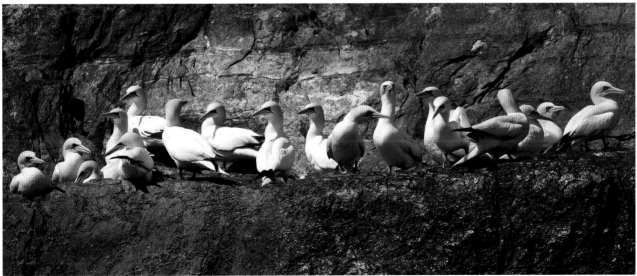

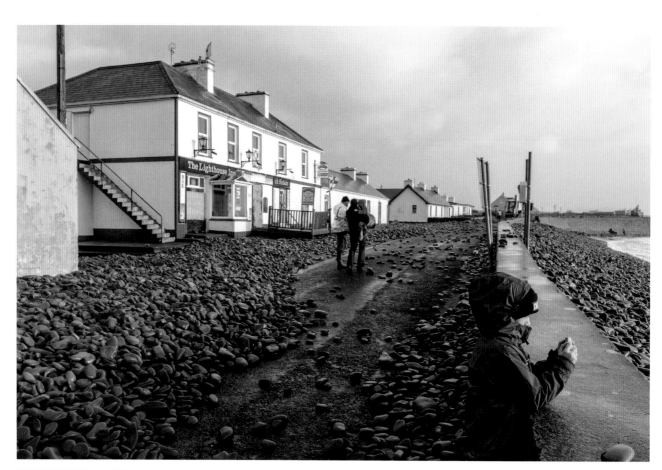

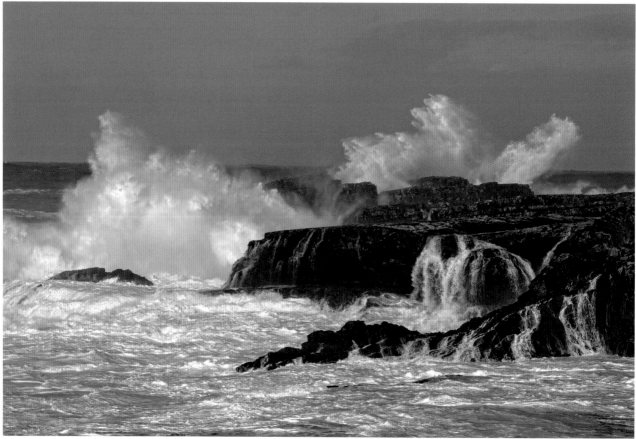

Even today the west can seem to be a few steps behind; in many rural areas roads are narrow and winding and in places mainly consist of potholes, broadband internet only exists on paper, the trip to the nearest supermarket can be an expedition and exotic beverages like latte macchiato or cappuccino only found their way onto the menu in the past decade. But these imperfections (or whatever you might like to call them) are also what make the spirit of the west: you don't take life too seriously you just get on with it. Here you will always find someone for a chat and a cup of tea or to help you out in any imaginable way. And if the electricity fails again over Christmas you just put on a few candles and roast the turkey on the camping cooker as best you can.

I have been photographing what is now the Wild Atlantic Way for almost twenty years, first as a visitor and then as a residential blow-in to a small village at the shores of the Atlantic Ocean. This book was a great opportunity to hit the road once more to make some new images, but also to dive deep into my archives and discover and re-discover images I had made in the past. The result is both a portrait of the landscape, heritage and people along the Wild Atlantic Way as well as a retrospective of my photographs of the past decade or so.

During my travels I had some memorable moments like a beautiful summer evening at Sheep's Head with no other soul around, or that day in Donegal where low cloud and constant drizzle created a magic atmosphere at Kinnagoe Bay. Unfortunately there are also the images I wanted, but couldn't make for this book: a summer sunset at Bloody Foreland (wet and windy weather got in the way), the view from Carrauntoohill, Ireland's highest peak (wet and windy weather got in the way) and the mesmerising landscape of Ballycroy National Park (wet and … you know) to name a few.

I can't finish this introduction without mentioning the winter of 2013/14, which has been officially baptised as the stormiest in 143 years. A series of violent storms that started at Christmas 2013 and went on into February 2014 destroyed parts of Ireland's west coast just in time for the official launch of the Wild Atlantic Way. Walls and roads were washed away, massive boulders were thrown many metres inland and whole sandy beaches just disappeared. It was an impressive reminder (and photographic opportunity of a lifetime …) that we are still at mother nature's mercy here at the Wild Atlantic Way.

Carsten Krieger,
September 2014

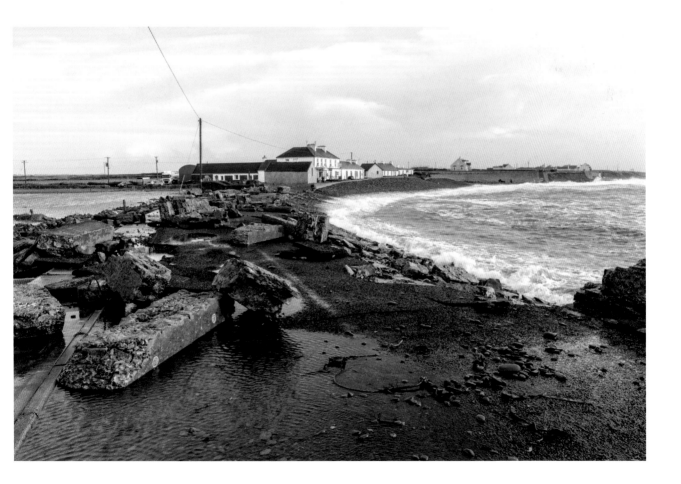

DONEGAL-MAYO

'Up here it's different' was the marketing slogan for Co. Donegal and as far as slogans go this one hits the nail on the head. Donegal truly is different. Geologically the north western corner of Ireland belongs to North America; it was once part of a landmass called 'Laurentia', while the rest of what would become Ireland lay several thousand miles to the south. Around 400 million years ago these two parts of Ireland collided and over time formed a single landmass. Maybe its connection to America is the reason that everything in Donegal feels that bit more dramatic: the cliffs appear that bit higher, the sandy beaches that bit longer and the mountains that bit more menacing.

Further south the counties Sligo, Leitrim and Mayo are gentler, but equally beautiful with a range of scenery that offers something for everybody. There are some of Ireland's best beaches for surfing along the way at Bundoran and Enniscrone. Those wanting to get away from everything will find peace and quiet in the wide, windswept spaces of Erris and the Mullet Peninsula. Further south lies Achill Island, Ireland's biggest and best-known island, and a place that has that special something that can't be put in words. It's a bit like a miniature Ireland, everything is there from sandy beaches, sheer cliffs, lakes, mountains, bogland to a variety of historic remains and a living heritage. Achill is at the northern entrance to one of Ireland's great bays and the end of this part of the journey: Clew Bay. Guarding its southern shores is Ireland's holy mountain and County Mayo's unmistakable landmark, Croagh Patrick also known as 'The Reek'.

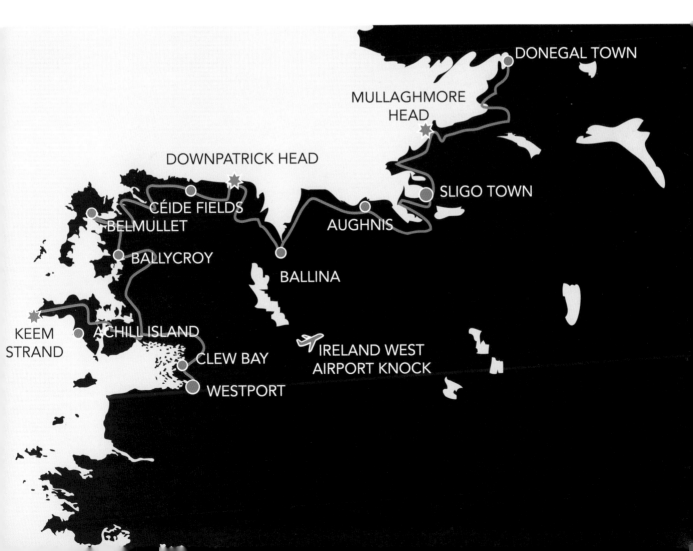

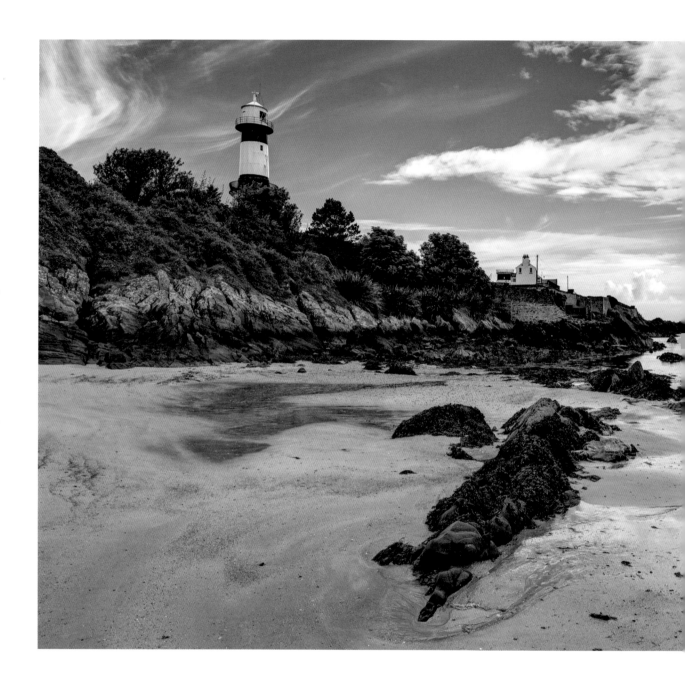

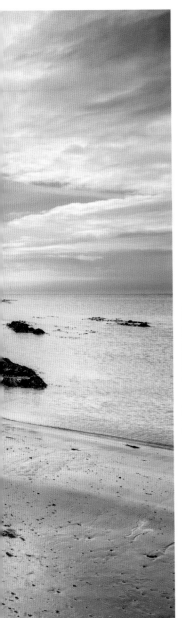

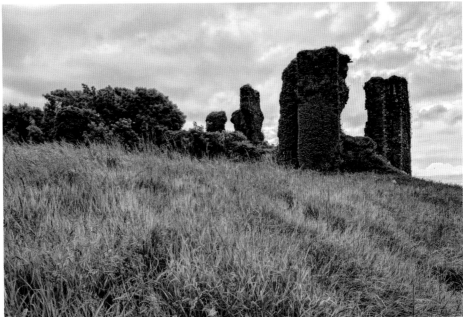

Left page: Inishowen Lighthouse, Greencastle, Inishowen Peninsula, County Donegal
Right page: Northburg Castle, Greencastle, Inishowen Peninsula, County Donegal

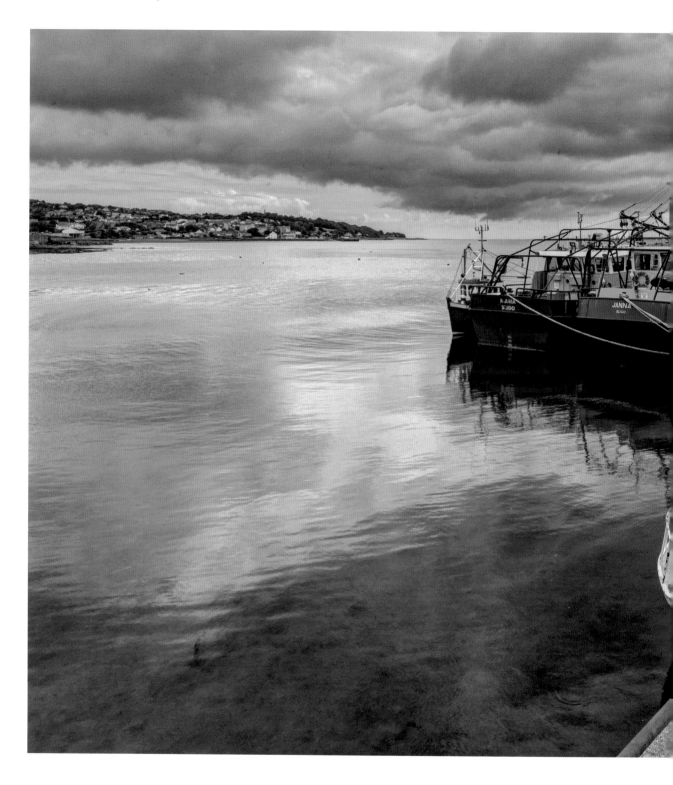

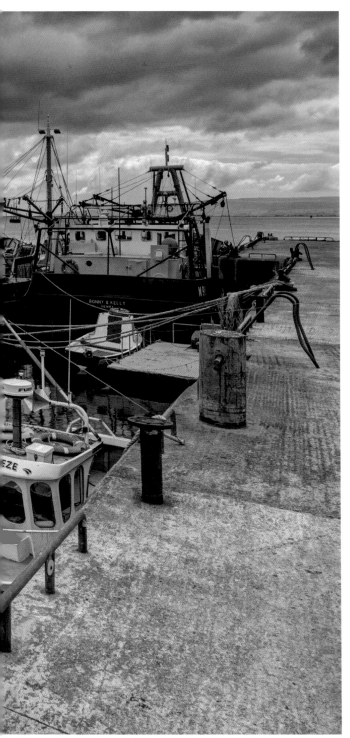

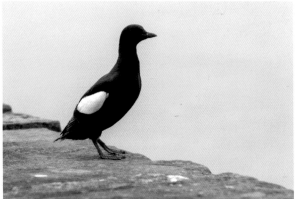

Left page: Moville Pier and Town, Inishowen Peninsula, County Donegal
Right page: Black Guillemots at Moville Pier, Inishowen Peninsula, County Donegal

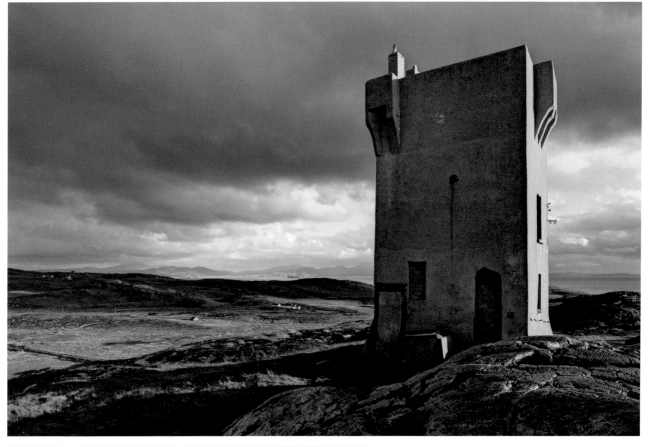

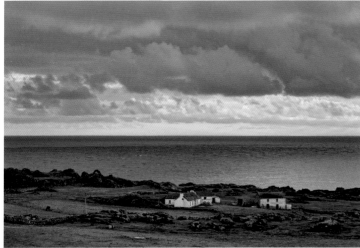

'Donegal is surely the most enchanting place in Ireland. Connemara is tribal and epic; Donegal is softer. If anything lies beneath the stony acres of Connemara it would be a battle axe lost in some old fight; in Donegal you might expect to unearth a crock of gold.'

H.V. Morton, In Search of Ireland

Top: The Tower at Malin Head, Inishowen Peninsula, County Donegal
Bottom: Cottage by the Sea, Malin Head, Inishowen Peninsula, County Donegal

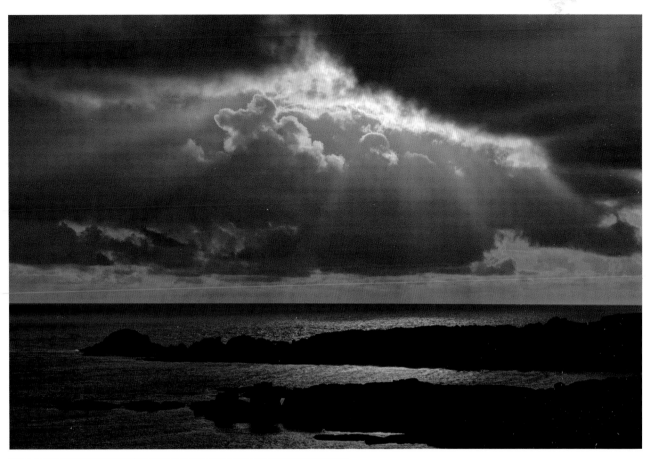

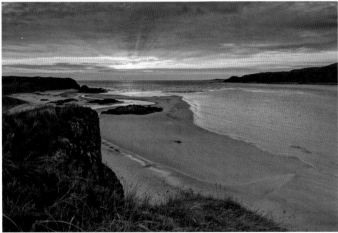

Banba's Crown' on Malin Head is the most northerly point on Ireland's mainland and named after Banba, a mythological figure and part of a triumvirate of goddesses and queens: Banba symbolises Ireland's warrior aspect, while her sisters Fódhla and Éire represent Ireland in the spiritual and earthly senses. The tower at Malin Head was originally built in 1805 as a lookout during the Napoleonic Wars and later became a signal tower for Lloyds of London using semaphore to connect to passing ships and the lighthouse on Inishtrahull Island north of Malin Head.

Top: Burst of Light, Malin Head, Inishowen Peninsula, County Donegal
Bottom: Trawbeaga, Inishowen Peninsula, County Donegal

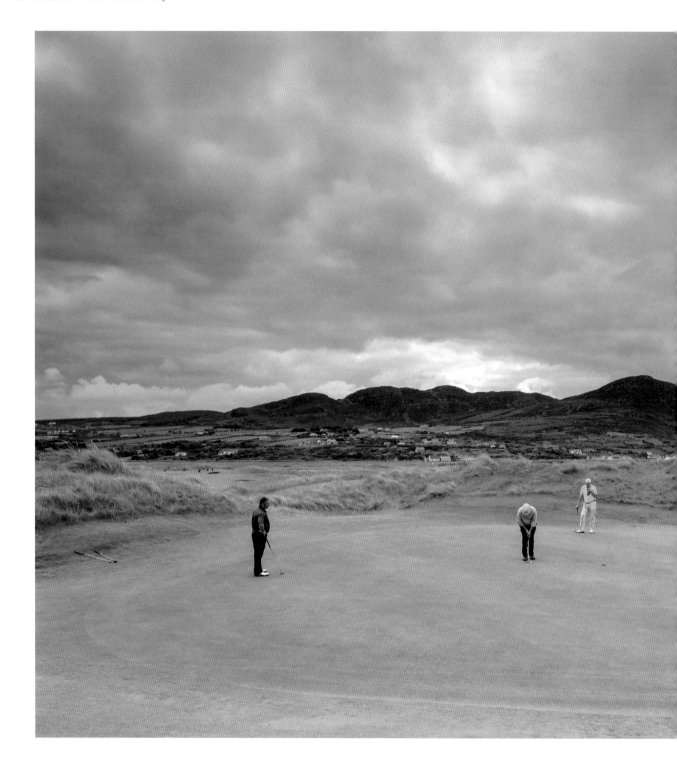

Right page top: Doagh Famine Village, Inishowen Peninsula, County Donegal
Right page bottom: Mary Doherty of Inishowen Bogwood Sculptures, Inishowen Peninsula, County Donegal. Mary Doherty has been sculpting bogwood for over fifteen years. The wood which can be over 6,000 years old is being sourced close to her home in Culdaff. It is then stored, dried and eventually being sculpted and sanded into the desired shaped and finished off with a coat of beeswax.
Left page: Ballyliffin 'Ireland's most northerly' Golf Club, Inishowen Peninsula, County Donegal

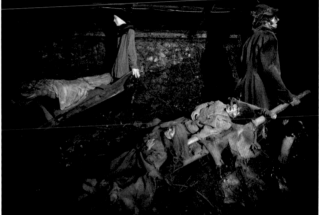

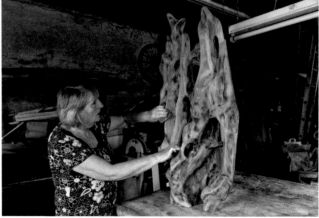

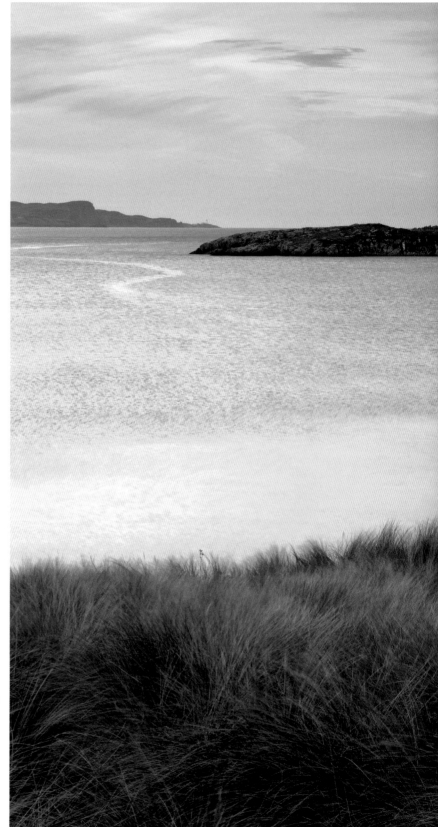

'I'd like to stay along with you, and while away the night, with fairy lore and tales of yore, beside the turf fire bright, and then to see laid out for me, a shake-down by the wall, for there's rest for weary wanderers, in the homes of Donegal.'

Traditional,
The Homes of Donegal

Left page: Lough Swilly from Dunree,
Inishowen Peninsula, County Donegal
Right page top: Temple of Deen,
Inishowen Peninsula, County Donegal
Right page bottom: Kinnagoe Bay,
Inishowen Peninsula, County Donegal

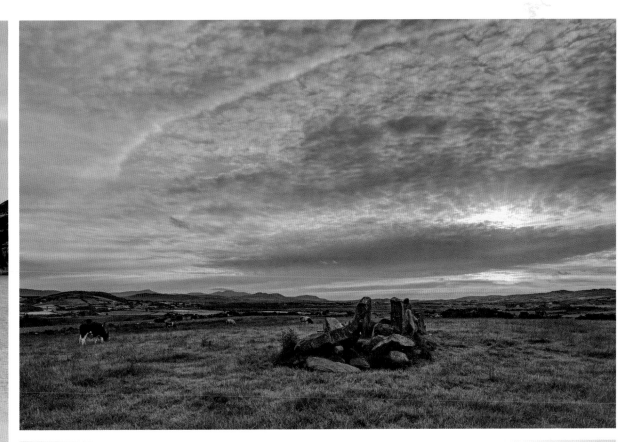

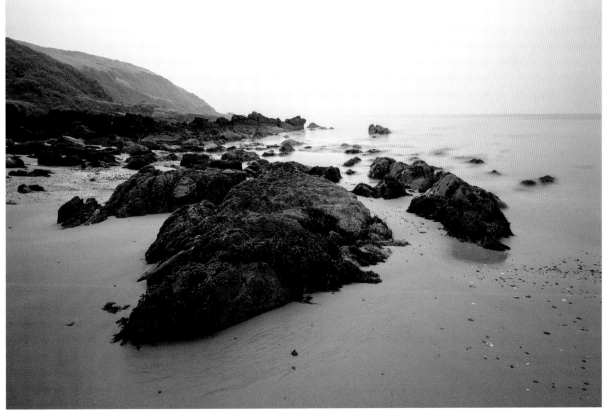

Brian McDermott is one of Ireland's foremost chefs and is looking back on a successful twenty-five-year career in the kitchen and food business. After a serious health scare in 2008 Brian completely changed his approach to cooking. He eliminated salt from his list of ingredients and replaced it with herbs and spices. Since then he has published the book Reunite with Food and became known as the No Salt Chef. He is running a cookery school in Moville and is hosting regular cooking demonstrations around Ireland and appears regularly on TV and radio.

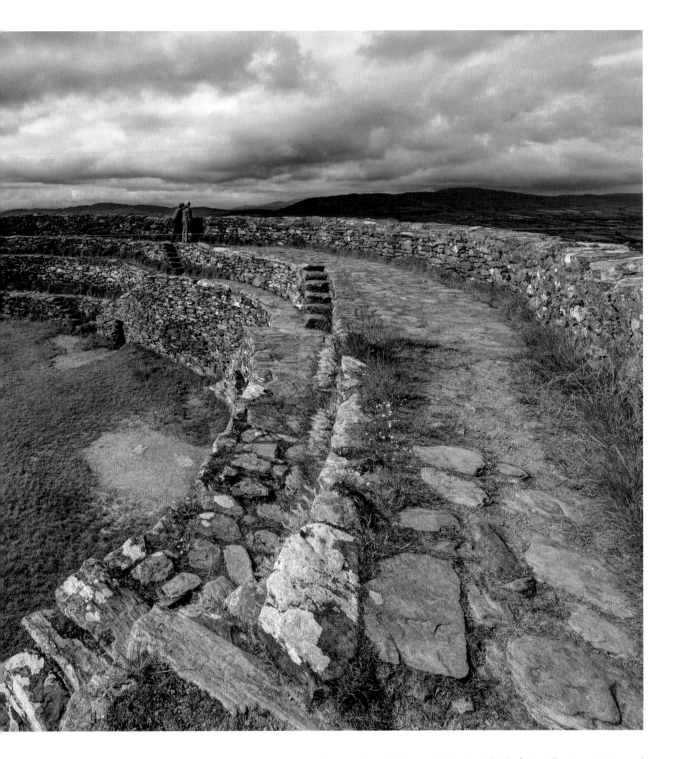

Left page: Brian McDermott 'The No Salt Chef', Moville, County Donegal
Right page: An Grianan of Aileach, Inishowen Peninsula, County Donegal. This ring fort, thought to date from the sixth or seventh century, is believed to have been the seat of the kingdom of Aileach, and ancient Irish kingdom.

'But we must return to "The Horn", perhaps the finest headland in Ireland. It rises sheer out of the ocean to over 600 feet, a great mass of hard quartzite with a conspicuous sill of diorite forming a dark band across the face of the cliff.'

Robert Lloyd Praeger, *The Way that I went*

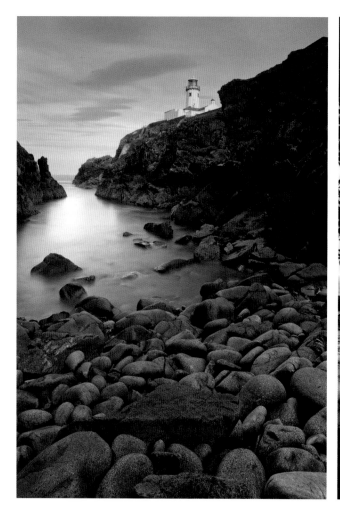

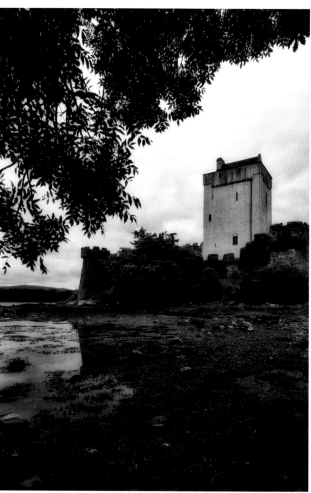

Left page left: Fanad Lighthouse, County Donegal
Left page right: Doe Castle, Creeslough, County Donegal
Right page top: Horse and Rider at Rathmullan Strand, County Donegal
Right page bottom: Horn Head, County Donegal

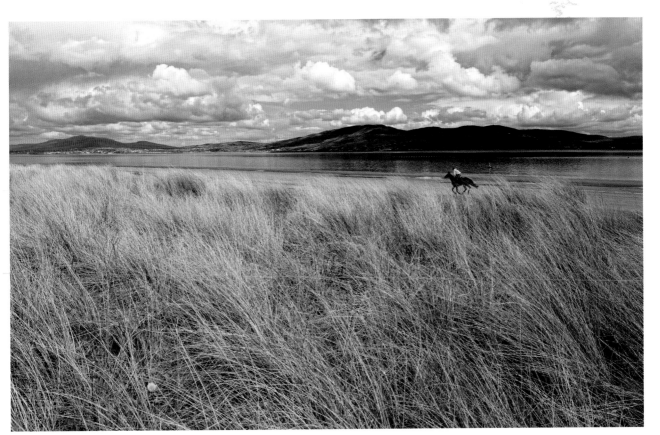

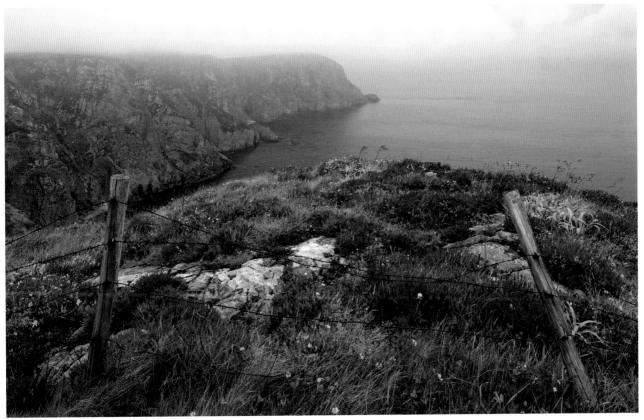

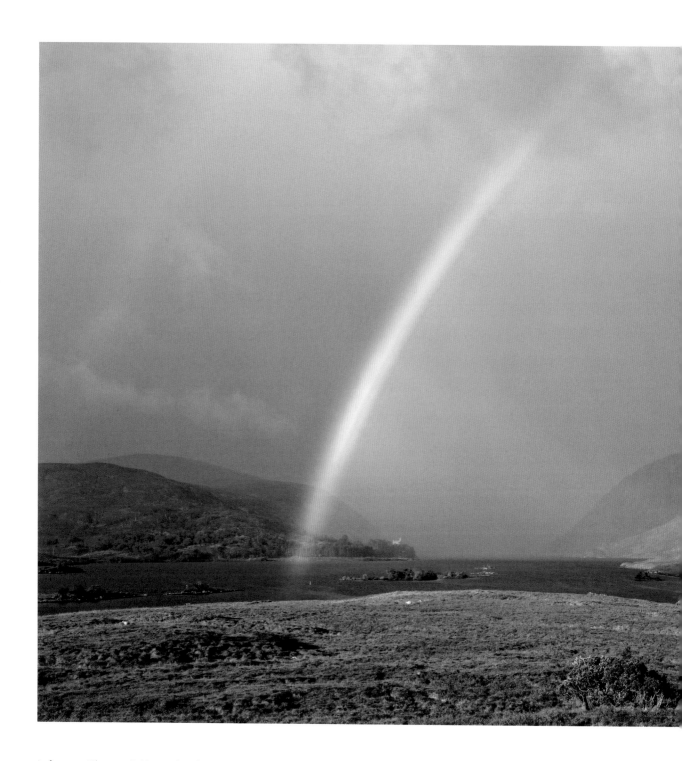

Left page: Glenveagh National Park, County Donegal. Glenveagh became a national park in 1975 and is a beautiful place to visit – 16,000 hectares in the heart of the mountains where visitors may catch a glimpse of golden eagles, deer and other wildlife.
Right page top: Loughanure, County Donegal
Right page bottom: Errigal, County Donegal's tallest mountain.

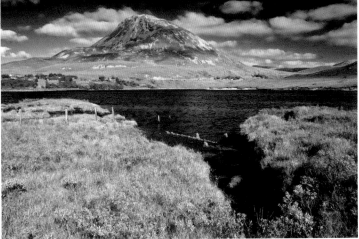

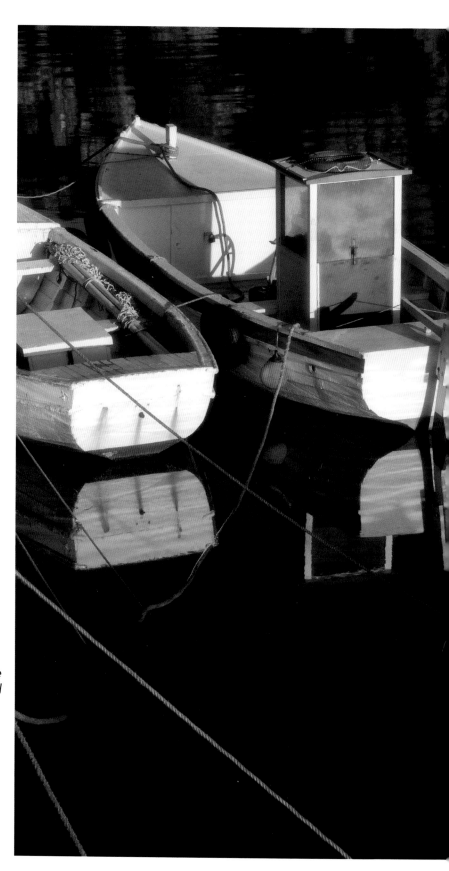

'I stopped on a lonely bog road one winter's afternoon to ask the way of a man who was stacking turf at the road's edge. 'Where will this road take me?' I asked. 'This road' he said, 'will take you wherever you want to go'.'
Mike Harding, *Footloose in the West of Ireland*

Left page: Bunbeg Harbour, County Donegal
Right page top: Maghery Strand, County Donegal
Right page bottom: Tramore Strand, County Donegal

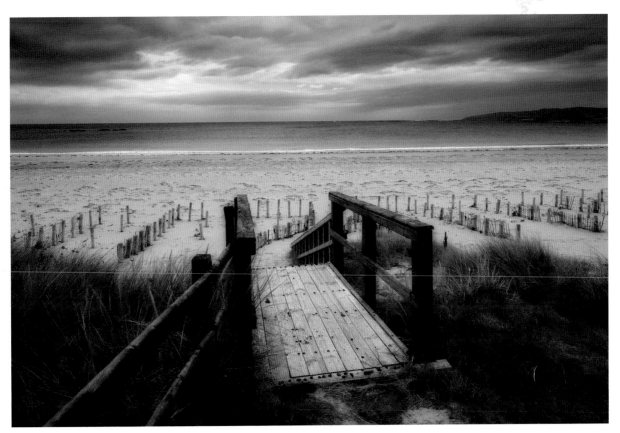

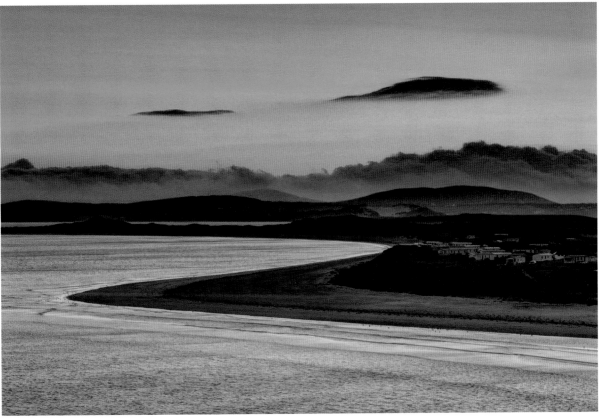

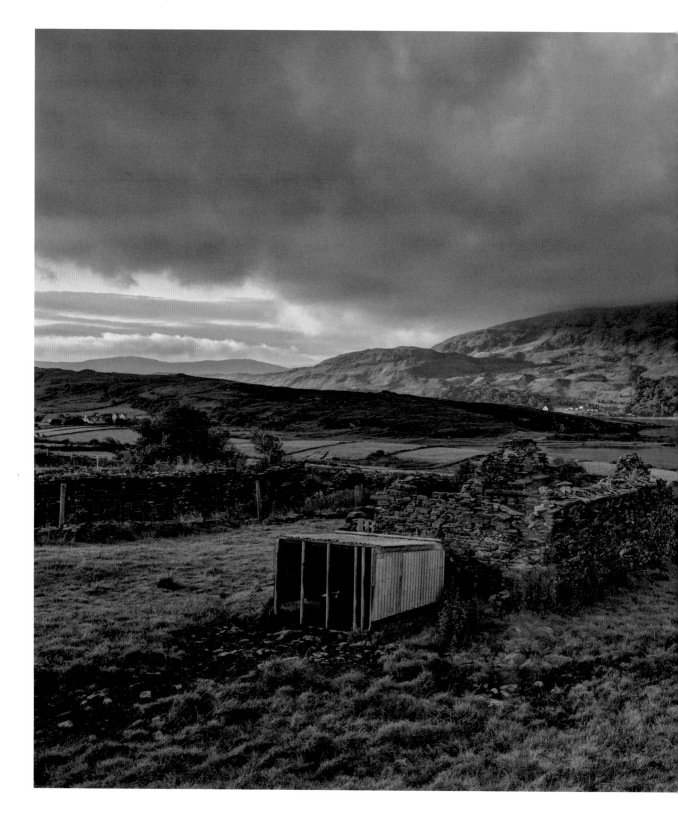

Left page: Loughros, County Donegal
Right page top: Essaranka Waterfall, County Donegal
Right page bottom: Maghera Caves, County Donegal

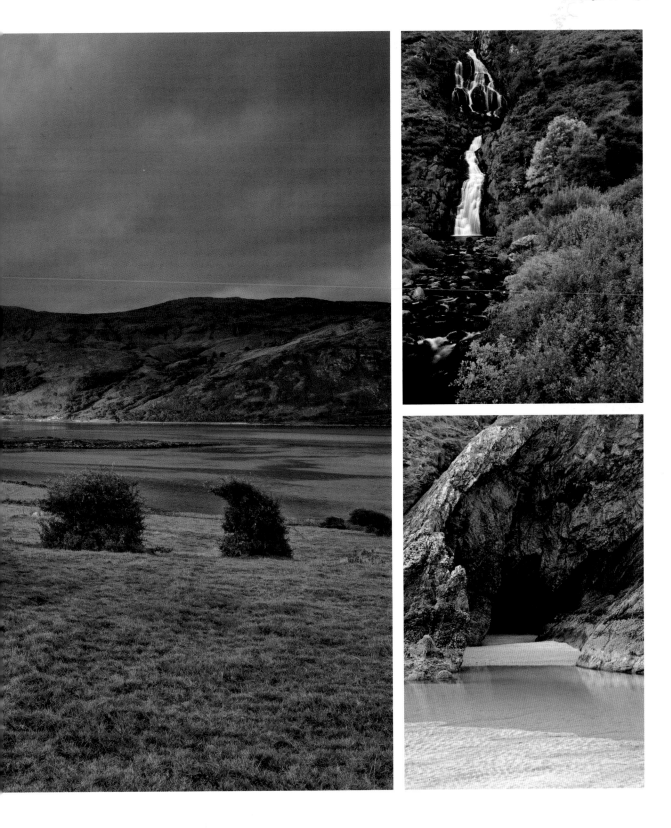

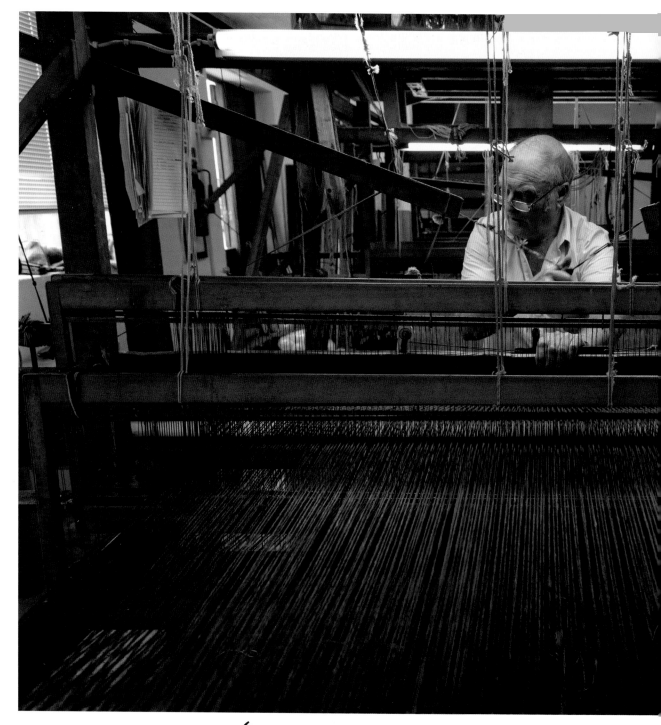

Donegal Tweed is known and cherished all over the world and has been made by hand entirely from local raw materials for centuries. The wool comes from sheep grazing on the Donegal hills and the colours have been extracted from the Donegal countryside: yellow gorse, orange lichen, red fuchsia and purple blackberries.

'Earthy browns of turf and moorland.
Gold of gorse and wheaten sheaves.
Greens of Ireland's meads and pastures.
Rusts of Autumn leaves.
Reds from mountain ash and bramble.
Drifting peat smoke's hazy grey.
Blues of slate, of sky, of speedwell.
White of hawthorn spray.'
 Bridget Haggerty, 'The Weavers of Donegal'

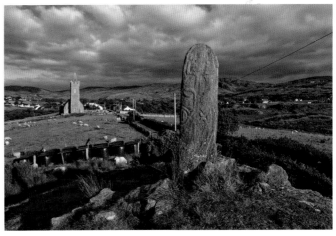

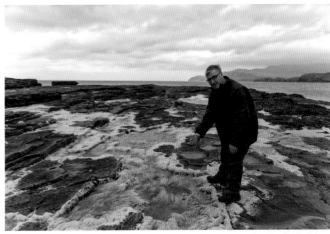

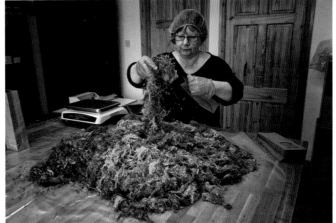

Left page: John from Studio Donegal at the weaving workshop, Kilcar, County Donegal
Right page top: Cross Pillar at Glencolmcille, County Donegal, one of Ireland's gaeltacht (Irish-speaking) areas
Right page centre: Michael from Algaran Seaweed harvesting Spirulina, Kilcar, County Donegal
Right page bottom: Rosaria from Algaran Seaweed, packaging the dried Spirulina, Kilcar, County Donegal

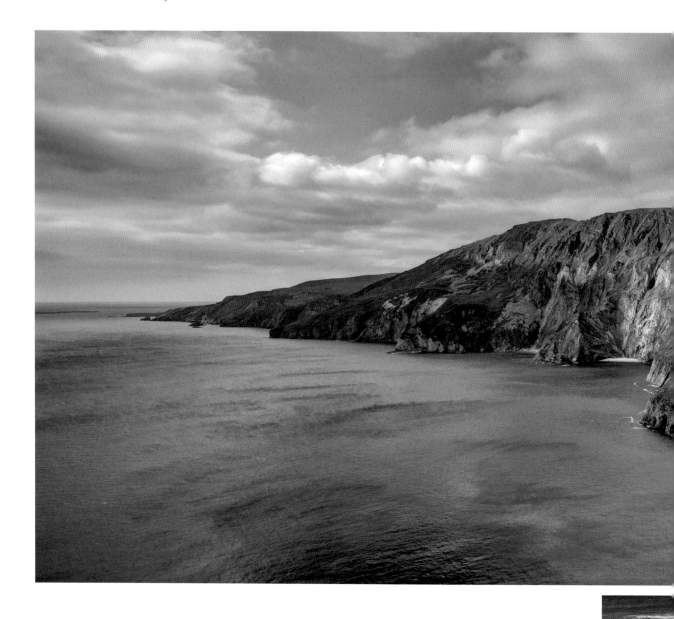

Top: Slieve League Cliffs, County Donegal. These are among the highest sea cliffs in
Europe and home to a variety of sea birds, like guillemots, puffins, razorbills and kittiwakes.
Right page left: Surfers on the beach, Bundoran, County Donegal
Right page right: Sunset Surf, Bundoran, County Donegal

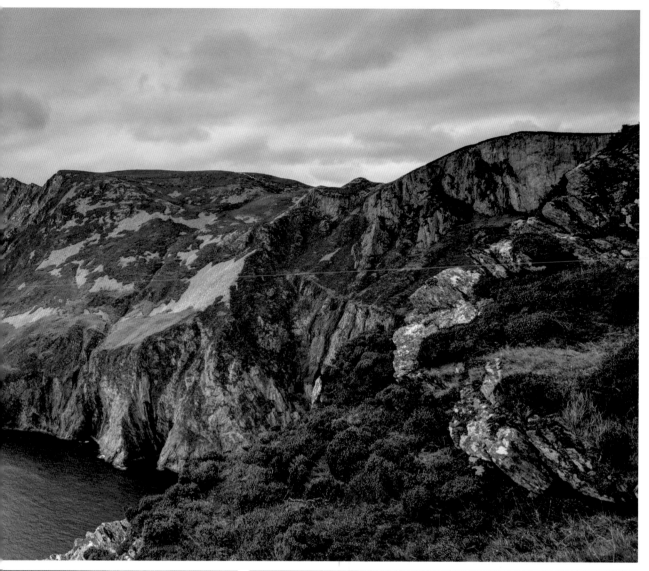

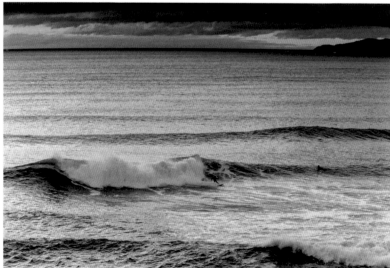

Six miles due north of Sligo, Ben Bulben dominates the landscape – a level topped mountain running westward till it drops in a 1500-feet cliff and talus to the low grounds that fringe the Atlantic. It and its name are symbols of what is quite one of the most picturesque as well as interesting areas in Ireland.

Robert Lloyd Praeger, *The Way That I Went*

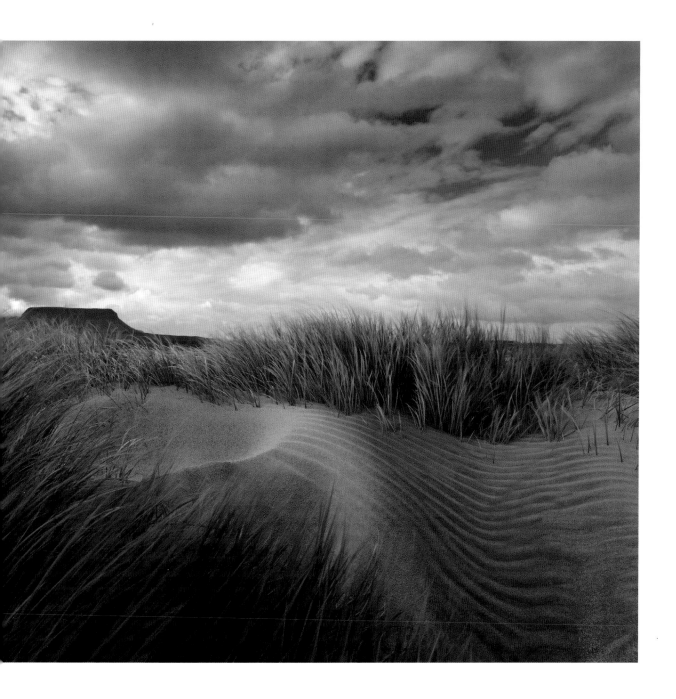

‘Cast a cold eye / On life, on Death / Horseman, pass by.’

The area around Lough Gill and Ben Bulben is inextricably linked to W.B. Yeats, one of Ireland's most famous poets, and is frequently referenced in his work. It is where he spent his childhood holidays and where he found his final resting place… in the shadow of Ben Bulben.

Left page top: Streedagh Strand, County Sligo
Left page bottom: Ben Bulben, County Sligo
Right page: Back Strand, County Sligo

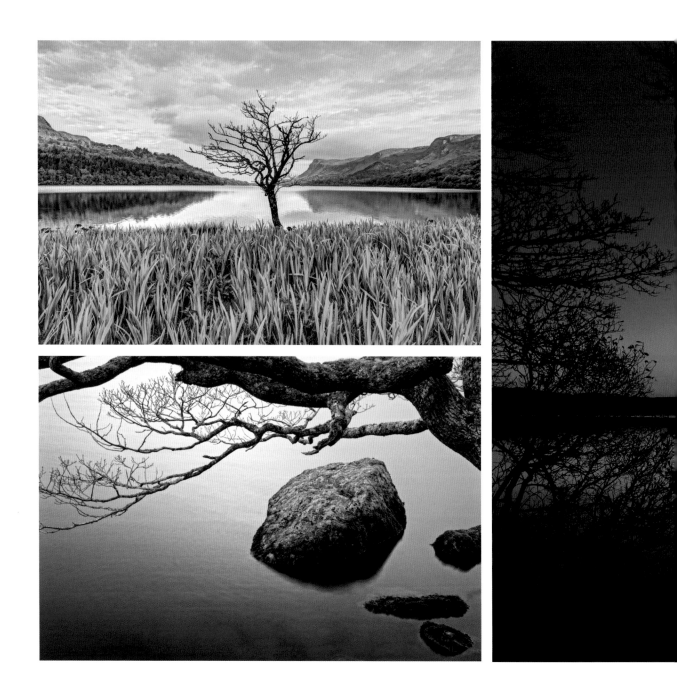

Left page top: Glencar, County Sligo/County Leitrm
Left page bottom: Lough Gill, County Sligo
Right page: Winter Dawn at Lough Gill, County Sligo

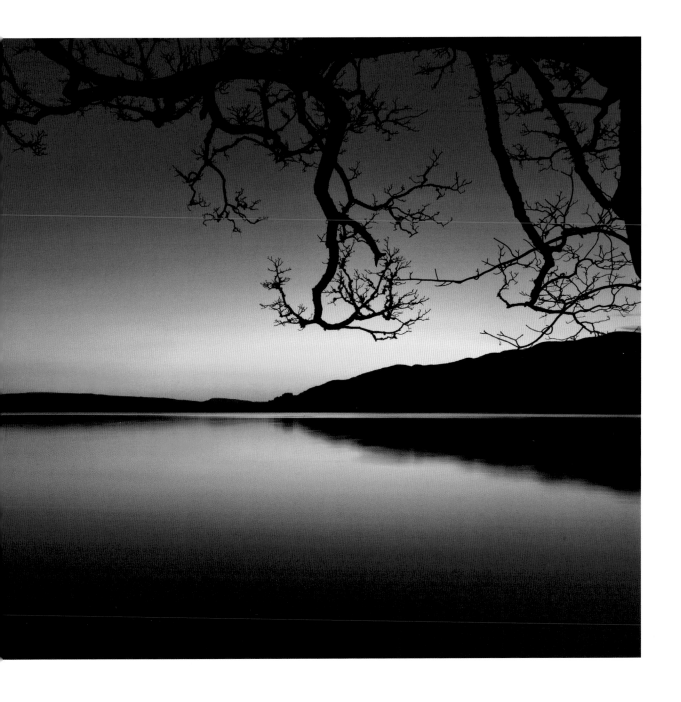

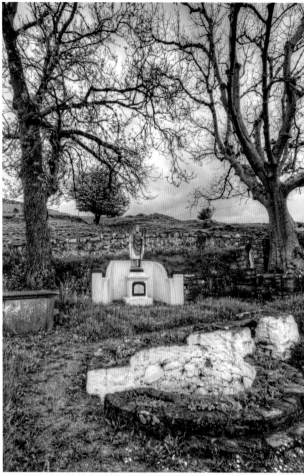

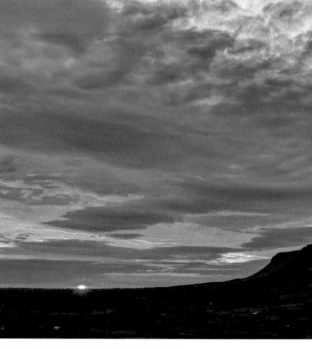

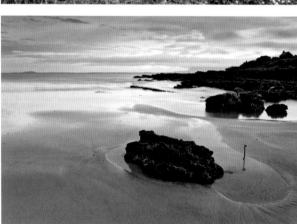

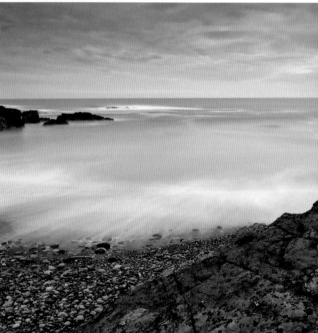

Left page top left: St. Patrick's Well, Dromard, County Sligo
Left page bottom left: Dunmoran Strand, County Sligo
Left page top right: Sunset with King's Mountain and Ben Bulben, County Sligo
Left page bottom right: Aughris Head, County Sligo
Right page: Castle Wall and Tree, Temple House, Ballymote, County Sligo

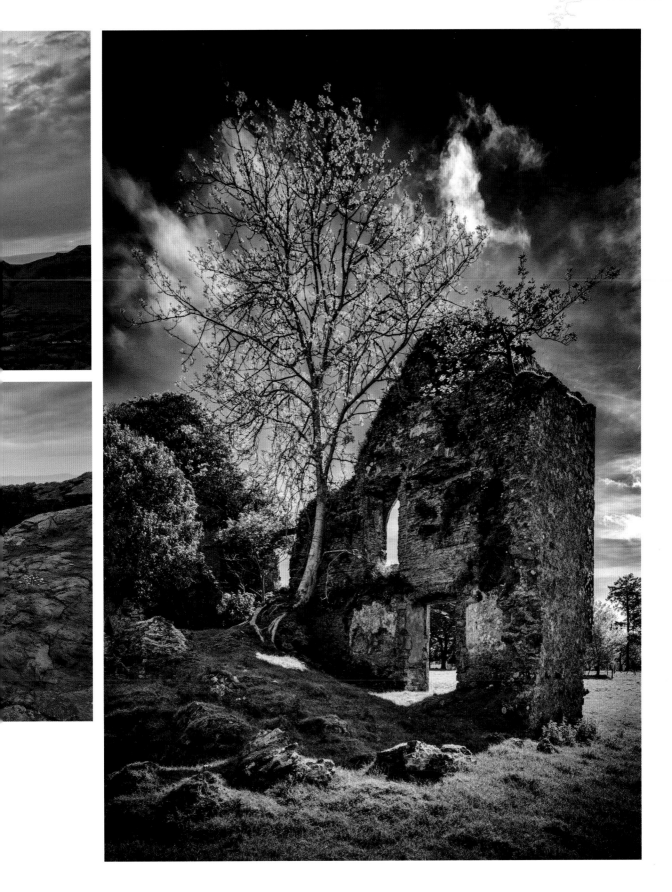

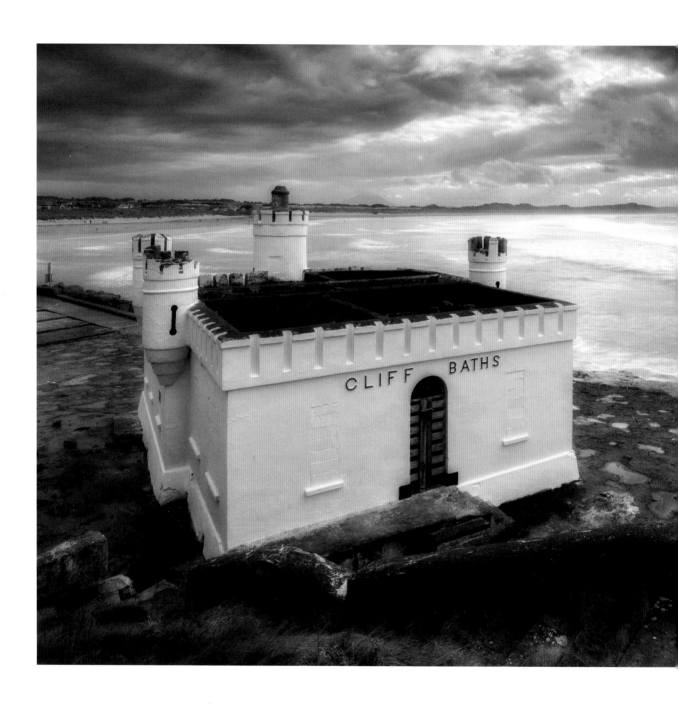

Left page: Cliff Baths and Beach, Enniscrone, County Sligo
Right page top: Old Pier and Boats, Killala, County Mayo
Right page bottom: Foggy dawn at Ross Strand, Killala, County Mayo

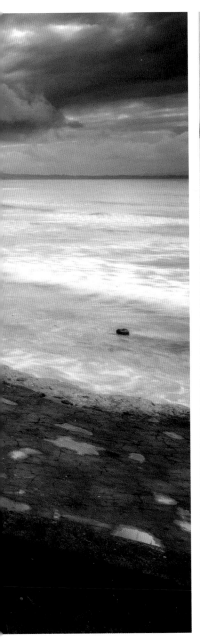

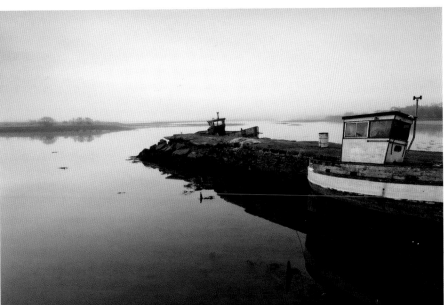

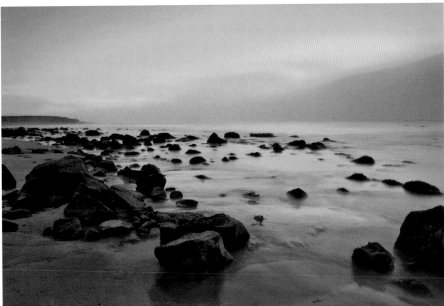

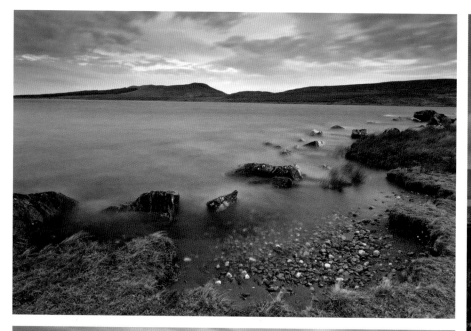

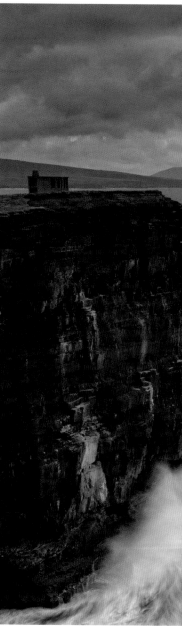

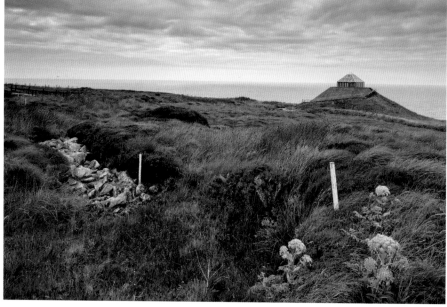

The Ceide Fields are the oldest field system in the world dating back some 5,000 years. The remains of field walls, houses and tombs have been preserved under a thick layer of blanket bog over several square miles. Parts of this Neolithic landscape has been excavated and offers a spellbinding view into the world of our ancestors.

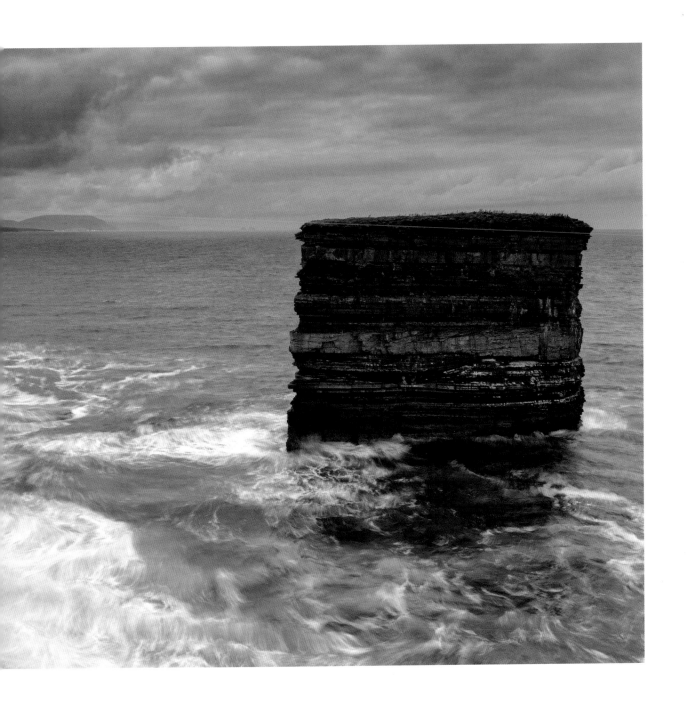

Left page top: Lough Easky, County Sligo
Left page bottom: Ceide Fields, County Mayo
Right page: Downpatrick Head and Dun Briste, County Mayo

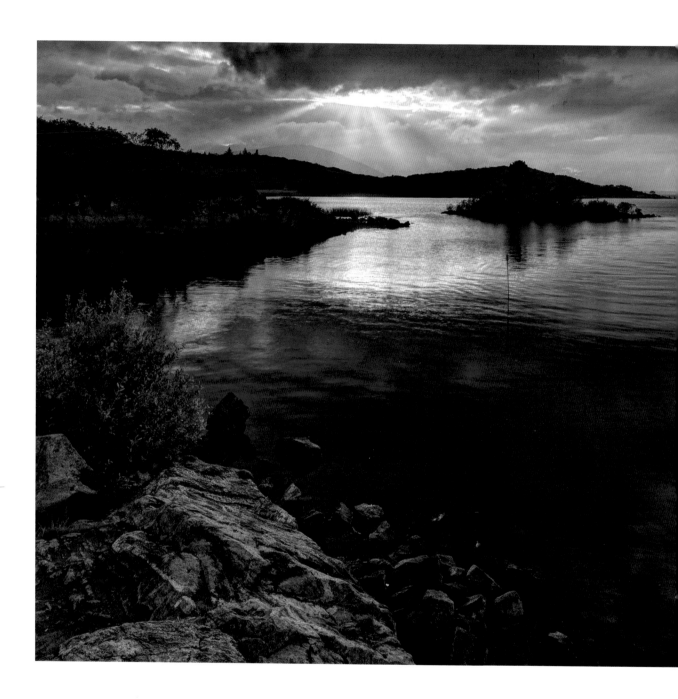

Left page: Sunset at Lough Conn, County Mayo
Right page top: Boat, Broadhaven, County Mayo
Right page bottom: The cliffs, sea stacks and arches of Benwee Head, County Mayo make for spectacular views.

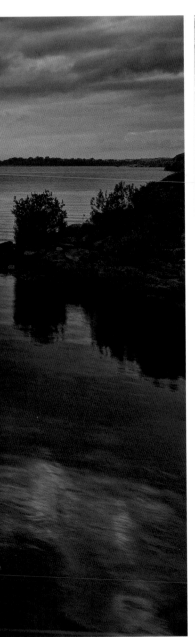

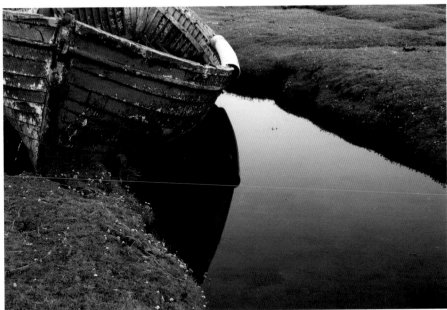

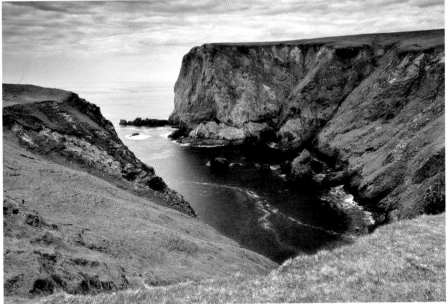

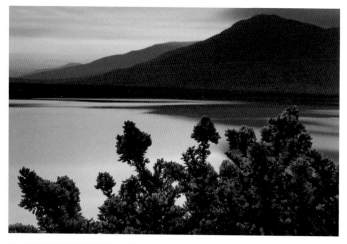

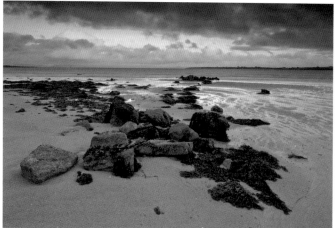

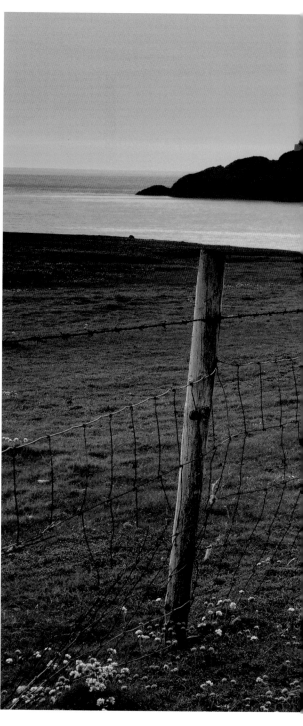

Left page top: Dawn at Bellacragher Bay, County Mayo
Left page bottom: Elly Bay, Mullet Peninsula, County Mayo
Right page: Eagle Island, Mullet Peninsula, County Mayo

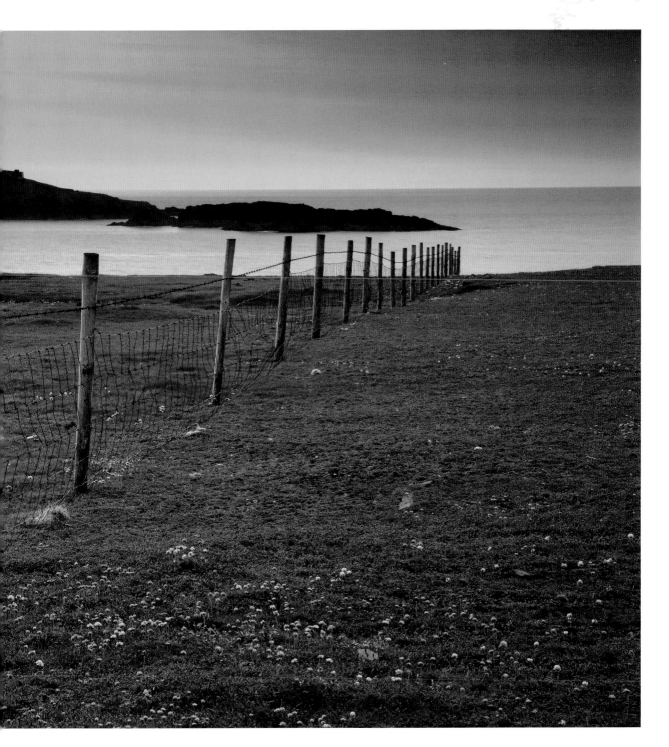

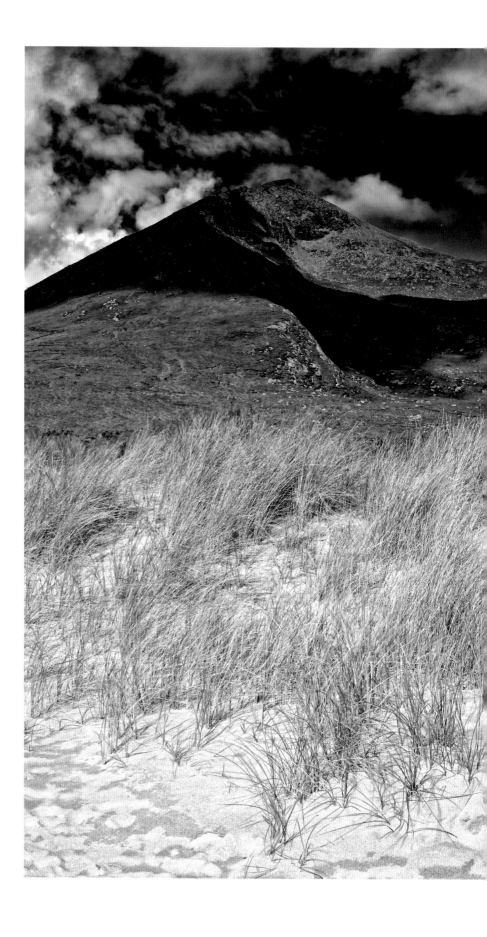

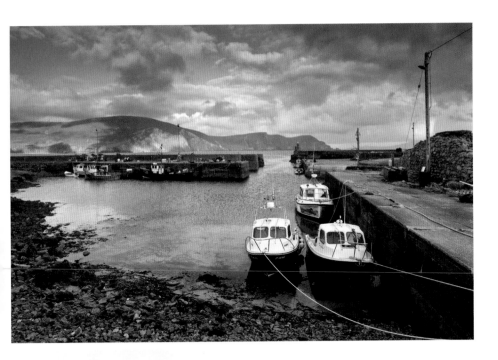

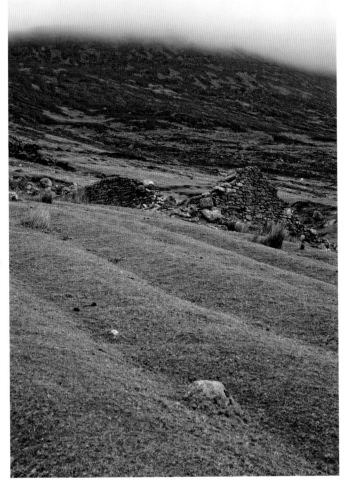

> ❛There is sorrow in it, as there is in all sharp beauty. Standing there with the gulls crying and the larks shivering in the sky and the wind going through the heather, a man gets cold with the beauty of it and is glad to be alone.❜
>
> H.V. Morton, *In search of Ireland*

Left page: Slievemore from Dooagh Strand, Achill Island, County Mayo; the island is connected to the mainland by a long bridge, so visitors can drive straight over.
Right page top: Pollagh Harbour and Menawn Cliffs, Achill island, County Mayo
Right page bottom: Deserted Village, Slievemore, Achill Island, County Mayo

'*Der Regen ist hier absolut, grossartig und erschreckend. Diesen Regen schlechtes Wetter zu nennen, ist so unangemessen, wie es unangemessen ist, den brennenden Sonnenschein schönes Wetter zu nennen.*'

Heinrich Böll *Irisches Tagebuch*

Above: Keem Strand, Achill Island, County Mayo. The world-renowned German author had a holiday home on Achill Island in the 1950s/60s. Today the Böll Cottage is a writers' retreat.

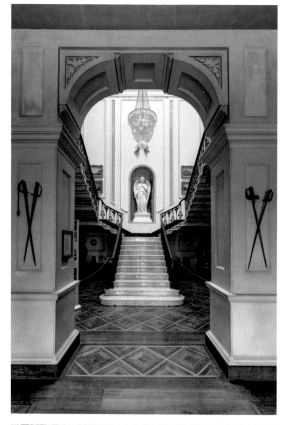

Grace O'Malley is one of those figures who make it hard to tell where history ends and legends begins. Grace (also known as Grany, Grane, Gráinne or Granuaile, from the Irish for 'bald Gráinne', because she is said to have cut off her long hair before heading to sea) was born around 1530 to an Irish chieftain who ruled the area around Clew Bay. Her first husband, Dónal O'Flaherty from Connemara, to whom she was married at around sixteen years of age, was killed in battle and it is at that time the legend begins. After Dónal's death she returned to County Mayo, took up residence on Clare Island and started the career that gave her the name 'Pirate Queen'. In the early days it is said that she only extracted taxes and fees from boats that passed through her territory, but over time she extended her activity all around the island of Ireland and evolved to attack ships as well as fortresses along the shore.

Today's owner of Westport House, the Eleventh Marquess of Sligo, is a direct descendant of Grace O'Malley and the house is built on the foundations of one of the many castles Grace owned along the west coast.

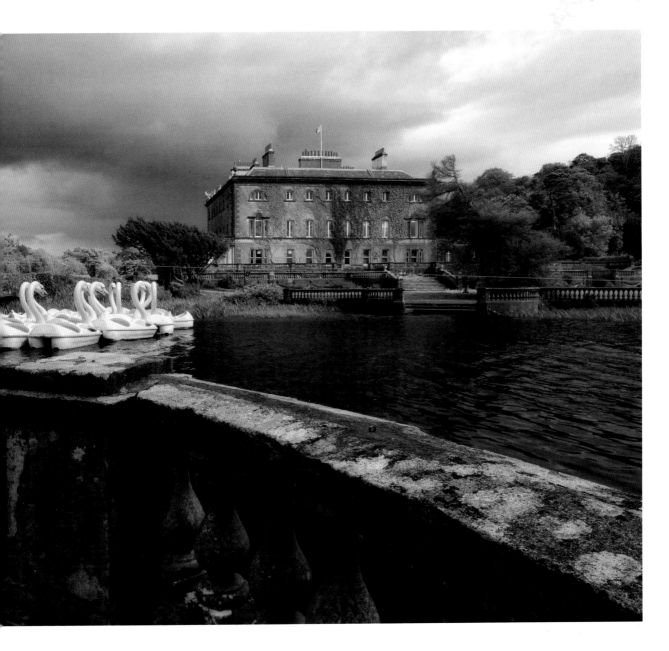

Right page: Westport House, County Mayo
Left page top: Entrance Hall, Westport House, County Mayo
Left page bottom: Grace O'Malley Statue, Westport House, County Mayo

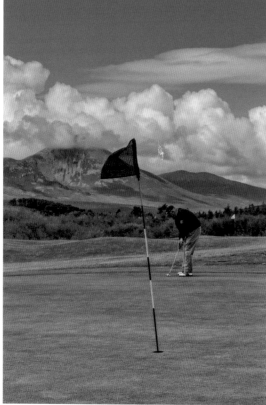

Left page top: Newport Church, County Mayo
Left page bottom: Westport Golf Club, County May
Right page: The Clock at Dawn, Westport, County Mayo

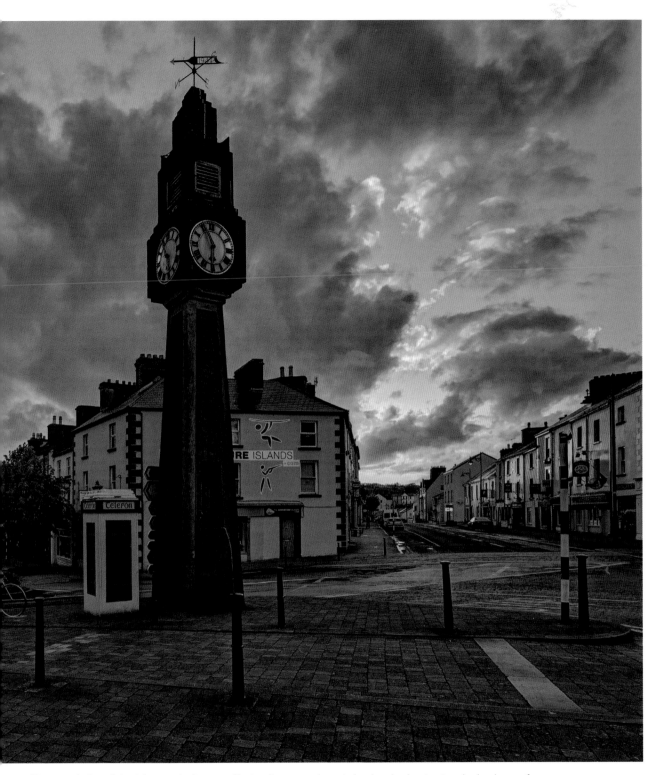

C roagh Patrick is without a doubt one of Ireland's most enigmatic landmarks dominating the landscape for miles around. According to legend, St Patrick spent forty days and nights of fasting and penance on the top of the mountain; Croagh Patrick is also where he banished snakes from Ireland forever. Archaeological excavations have discovered that Croagh Patrick has been of importance for thousands of years: Remains of a pre-Christian ring fort are encircling the mountain top and a dry stone oratory indicates that 'The Reek', as it is locally known, has been a place of worship since the earliest days of Christianity.

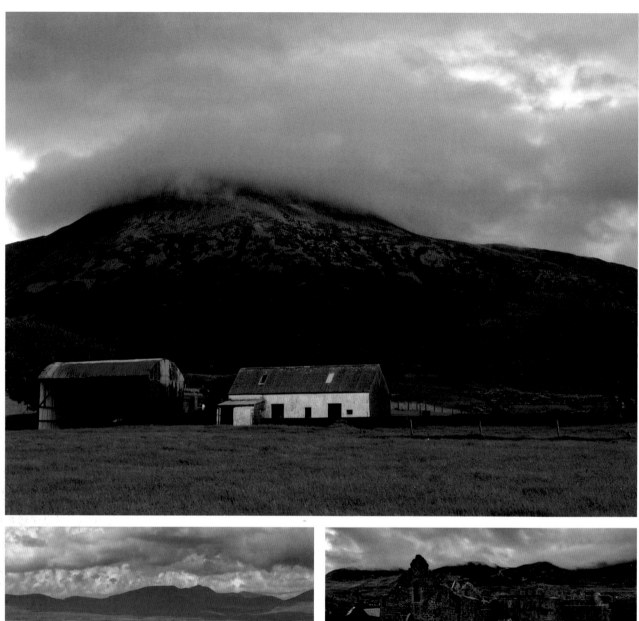

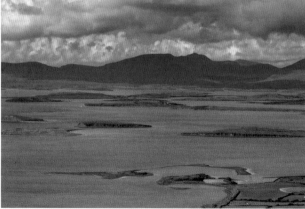

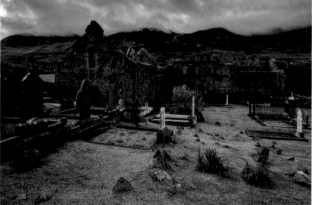

Top: Farm and Croagh Patrick, County Mayo
Bottom left: Clew Bay (from Croagh Patrick), County Mayo
Bottom right: Murrisk Abbey, County Mayo

MAYO-CLARE

The route from Westport in County Mayo to Loop Head in County Clare brings the traveller through the most diverse scenery along the Wild Atlantic Way. There are the intricate bays and inlets of Connemara overlooked by the granite mountain ranges of the Twelve Bens and Maumturk Mountains. Further south lies the limestone landscape of the Burren and some of the most dramatic cliffs of Ireland's west – the Cliffs of Moher and Loop Head. Some highpoints along this part of the journey are Ireland's only fjord, Killary Harbour, the workshop of master bodhrán maker Malachy Kearns in Roundstone, Europe's biggest stalactite in the Doolin Cave and of course the music: the County Clare villages of Kilfenora, Lisdoonvarna and Doolin are synonymous with Irish traditional music or to quote Christy Moore: 'Flutes and fiddles everywhere. If it's music you want you should go to Clare.'

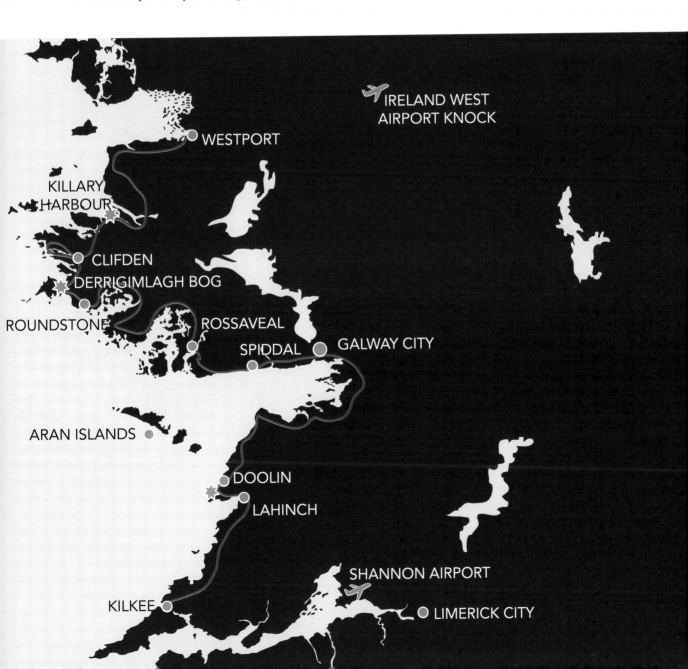

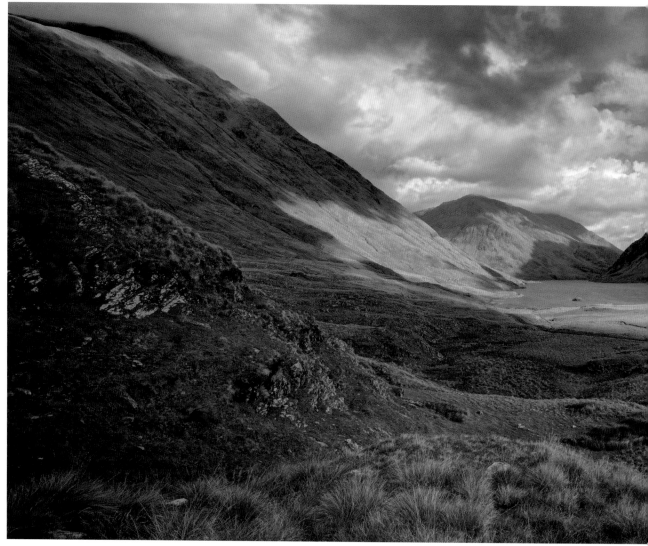

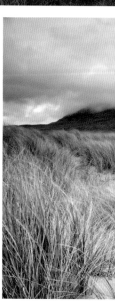

The Doolough Pass that cuts through the Mweelrea Mountains and Sheefrey Hills is one of the most haunting places in Ireland. It is as if the landscape holds the memory of one of the greatest tragedies of the Irish Famine. On 30 March 1849 two officials were to assess people in Louisburgh for continued receipt of outdoor relief: food and clothing for the poorest of the poor. For some reason, however, the officials decided to head straight for the hunting lodge in Delphi, nineteen kilometres south of Louisburgh. The people were told to report there the following morning at 7am. Hundreds of men, women and children undertook the journey on foot, badly clothed and starving, in driving rain and almost freezing temperatures. The assessment never took place and later that day the men, women and children were told to return to Louisburgh. The weather had deteriorated further and night was falling. The accounts of how many lost their life that night varies, what is certain is that hunger, exhaustion and the icy waters of the lake claimed many. Today, an annual 'Famine Walk' from Louisburgh to Doolough commemorates the tragedy.

Top: Doolough, County Mayo
Bottom left: Silverstrand, County Mayo
Bottom right: Old Head Pier and Croagh Patrick – known as 'Ireland's Holy Mountain'

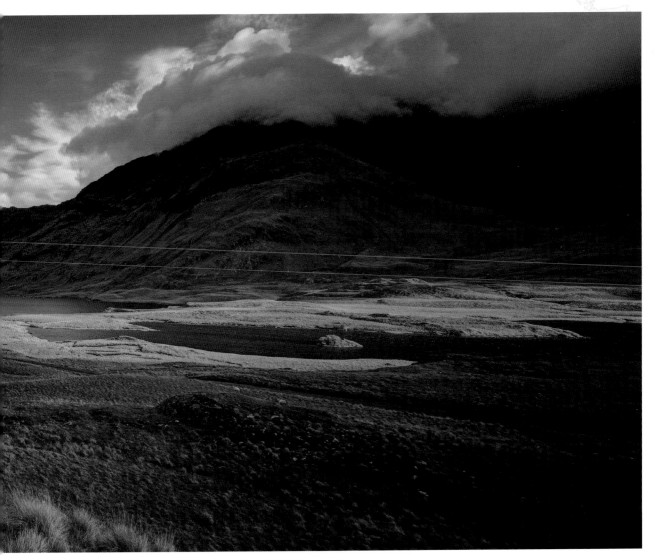

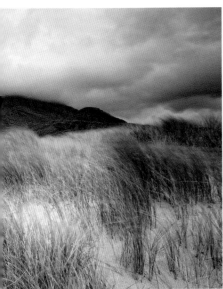

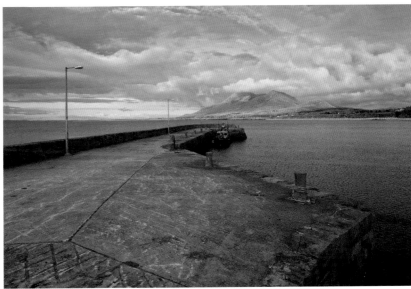

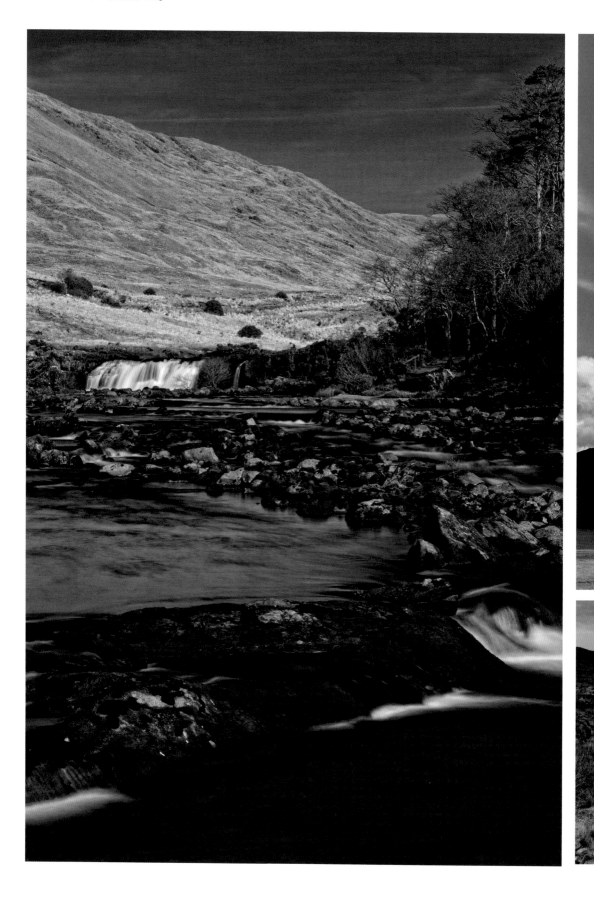

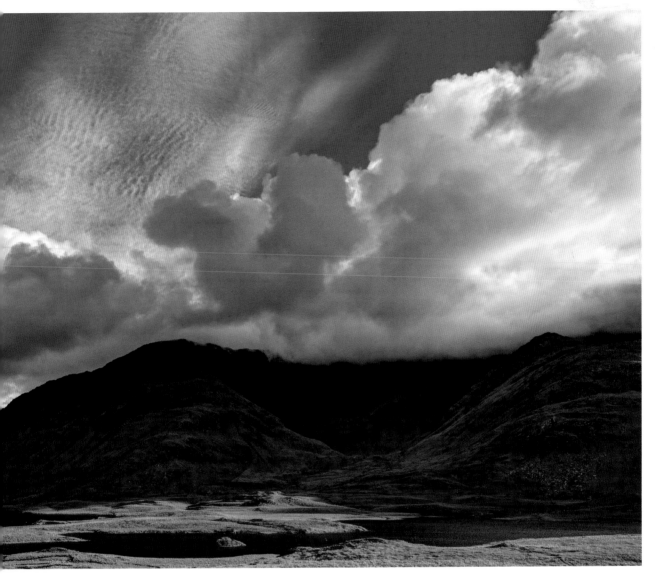

Killary Harbour is a narrow coastal inlet, stretching for some sixteen kilometres and surrounded by steep mountains. Known as 'Ireland's Only Fjord', it was formed around 20,000 years ago along a natural fault line that caused a westward movement of massive glaciers. These glaciers cut deep into the bedrock; Killary Harbour is 45 metres in depth. At the top of Killary Harbour is Leenaun, a small village popular with mountaineers who can take advantage of four mountain ranges (Twelve Bens, Maumturks, Sheefries and Partry) only a hop away, and with film buffs that want to experience the landscape that inspired *The Quiet Man* and *The Field*.

Left page: Assleigh Falls, Connemara, County Galway
Right page top: Mweelrea Mountains, Doolough, County Mayo
Right page bottom: Old Pier, Killary Harbour, Connemara, County Galway

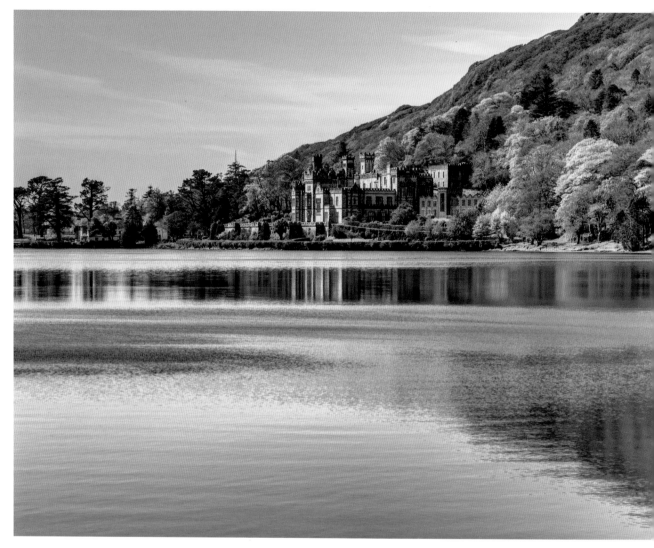

'Neither a map nor a text can do justice to the web of cross-references that Time, the old spider, has spun across the spaces of Connemara.'

Tim Robinson

Left page top: Kylemore Abbey, Connemara, County Galway
Kylemore began life as a castle, before becoming a community for Benedictine nuns after the First World War. The nuns ran a school there until 2010; today Kylemore Abbey is open to the public and boast a Victorian Walled garden and tea rooms.
Left page bottom: The White Strand, Tully, Connemara, County Galway
Right page: Rag Tree at Killary Harbour, Connemara, County Galway

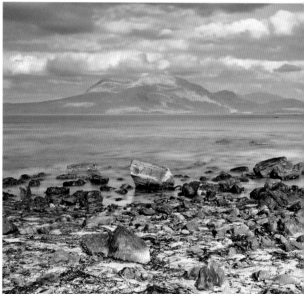

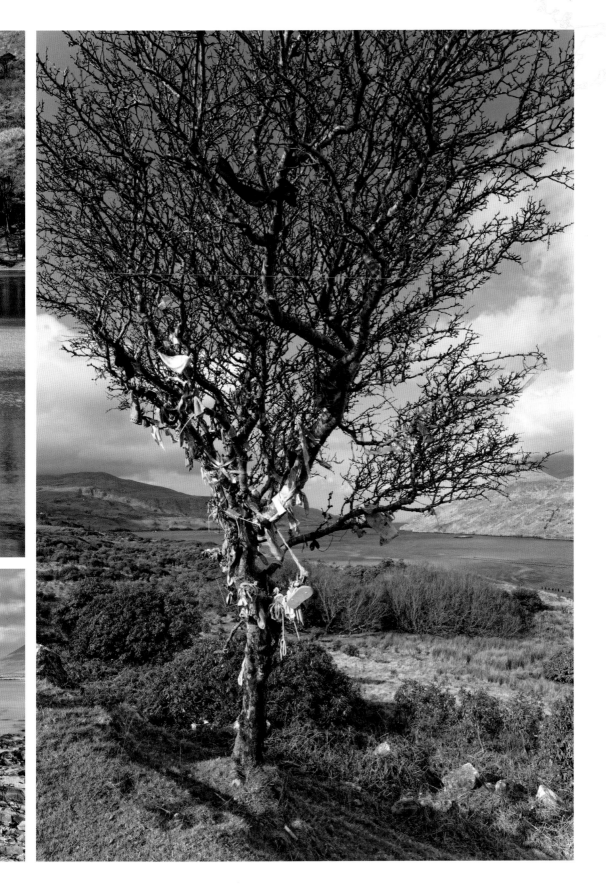

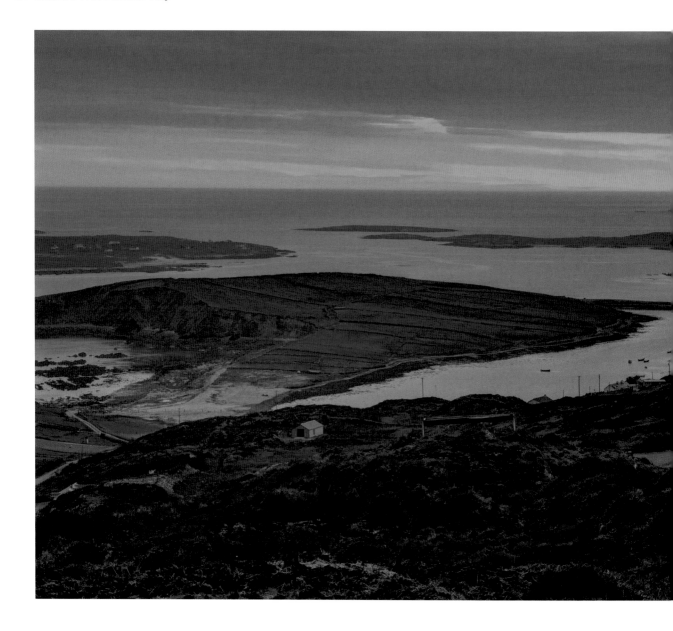

Top: Sky Road, Clifden, Connemara, County Galway
Right page bottom left: Last light on Errisbeg, Connemara, County Galway
Right page bottom right: Ballyconneely, Connemara, County Galway

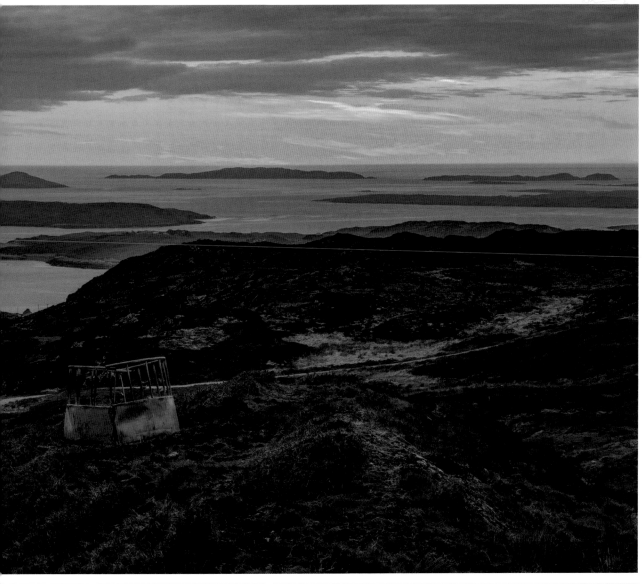

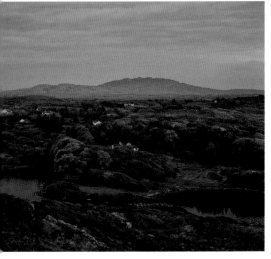

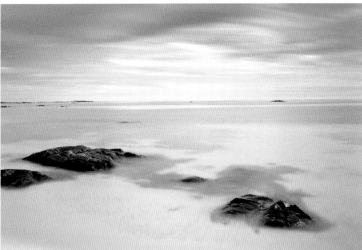

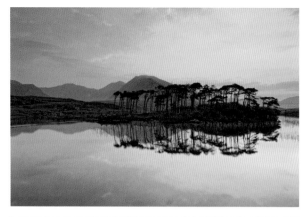

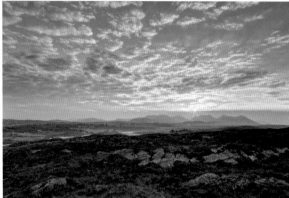

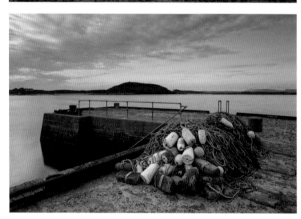

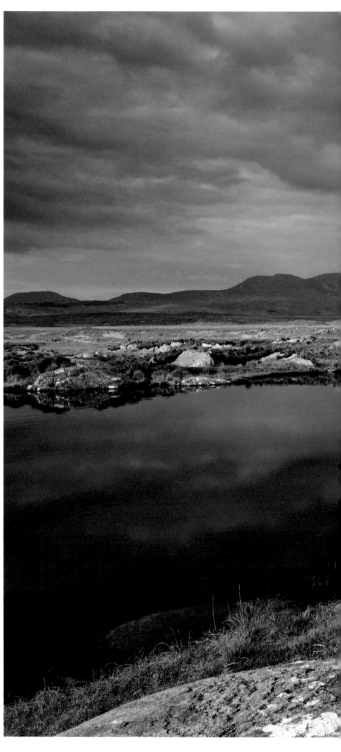

Left from top: Derryclare Lough, Connemara, County Galway
Sunrise over the 12 Bens, Connemara, County Galway
Bunowen Pier, Connemara, County Galway
Graham Roberts of the Connemara Smokehouse, Bunowen Pier,
Connemara, County Galway
Large image: Bog Pool, Roundstone Bog, Connemara, County Galway

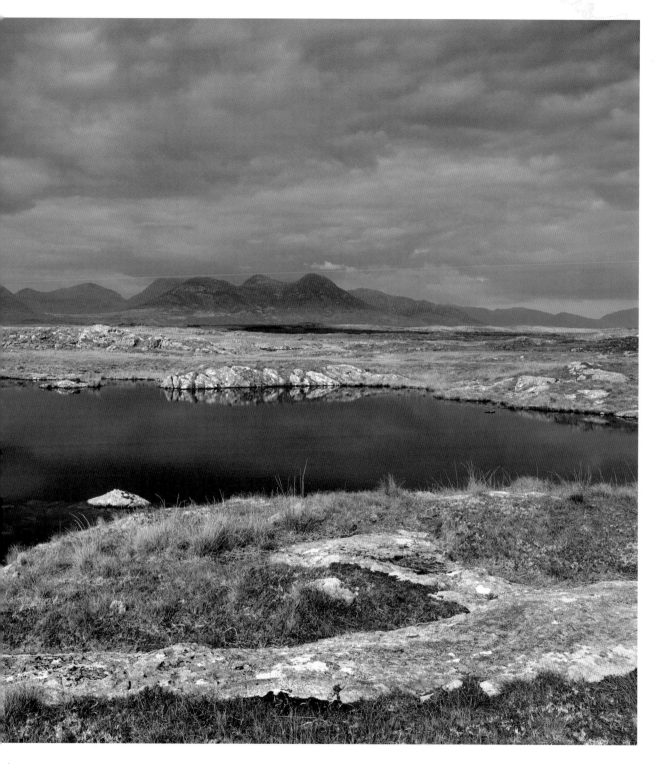

'On a day of bright sky, when the hills are of that intoxicating misty blue that belongs especially to the west, the bogland is a lovely far reaching expanse of purple and rich brown and the lakelets take on the quite indescribable colour that comes from the clear sky reflected in the bog-water, while the sea-inlets glow with an intense but rather greener blue. On such a day the wanderer will thank his lucky star that it has brought him to Connemara.'

Robert Lloyd Praeger, *The Way That I Went*

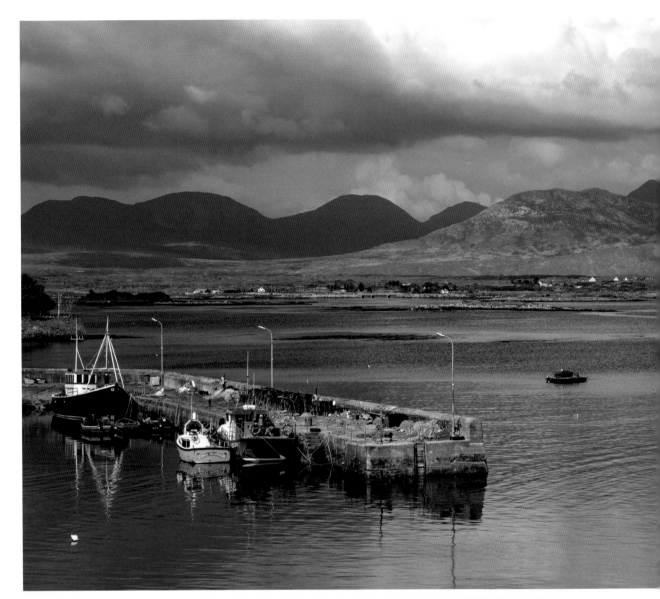

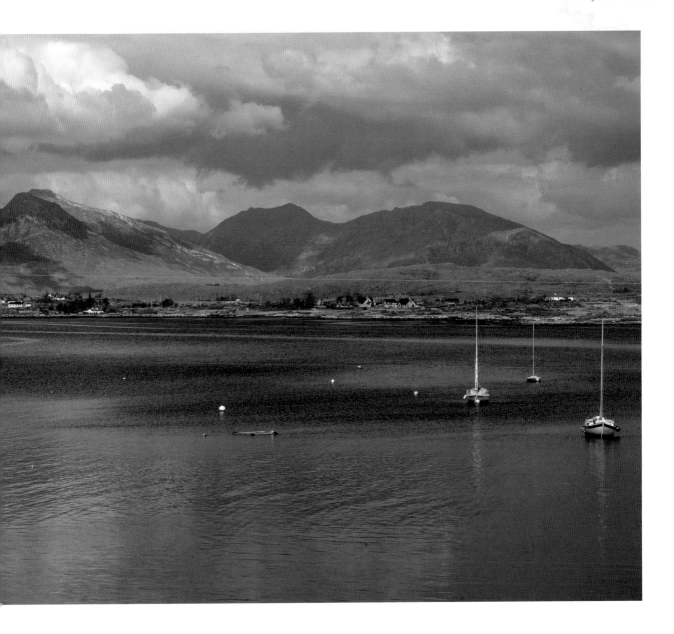

'Nothing is more picturesque in the British Isles than this
astonishing fishing village of neat, whitewashed, thatched
cottages planted at haphazard angles with no regular roads
running to them. It is a triumph of unconscious beauty.'
H.V. Morton 'In Search of Ireland'

Top: Roundstone Pier and Bay, Connemara, County Galway
Bottom left: Bodhráns at Malachy Kearn's workshop, Roundstone, Connemara, County Galway
Bottom right: Connemara Ponies, Connemara, County Galway

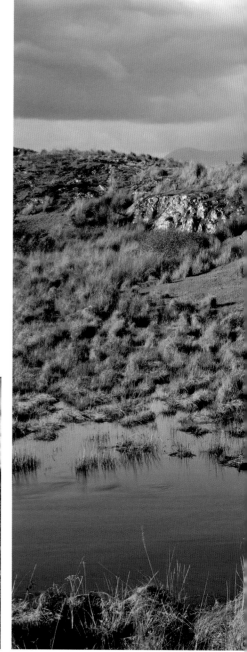

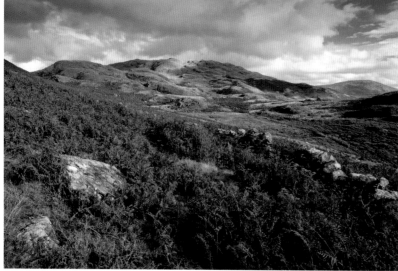

Left: Joyce's Country, County Galway
Right: Old Cottage by the river, Connemara, County Galway

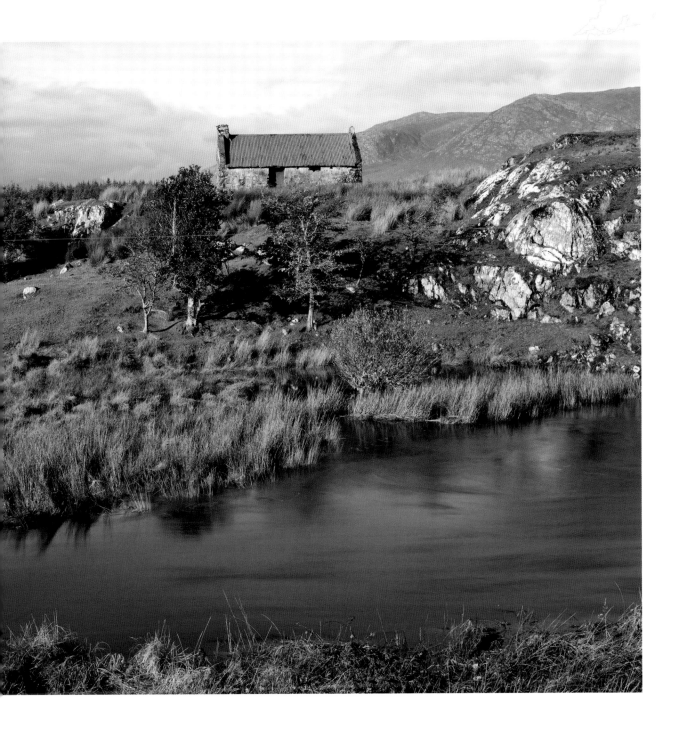

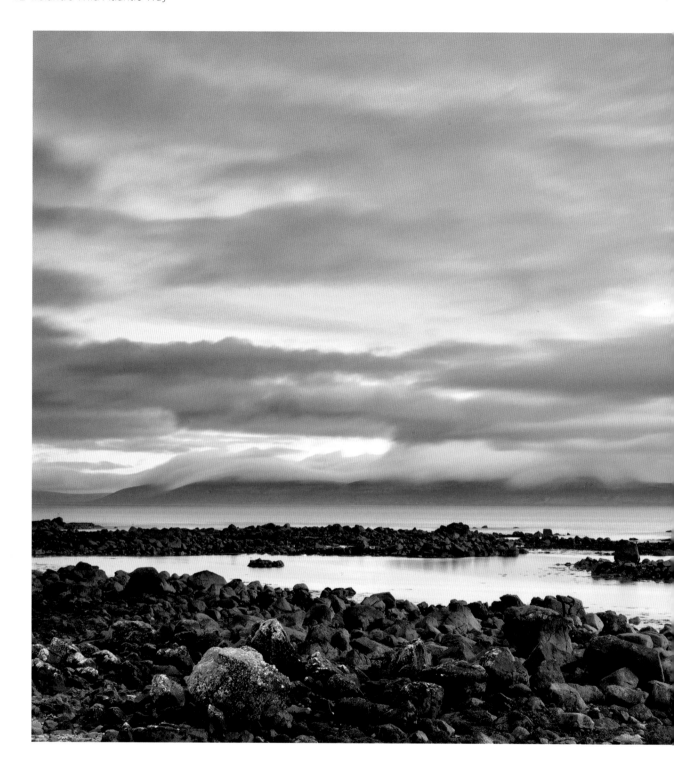

Left: The Burren hills seen from Na Forbacha, County Galway
Top right: Boats at Spiddal Harbour, County Galway
Bottom right: The Claddagh, Galway

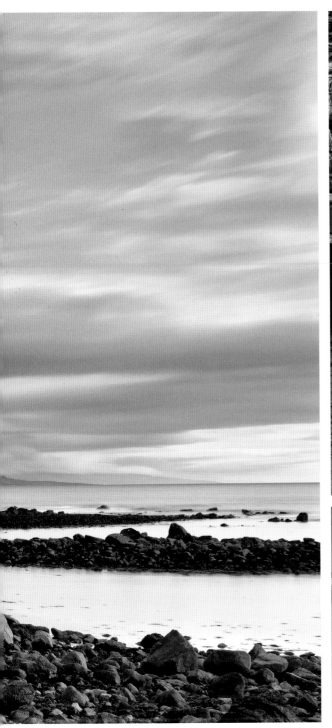

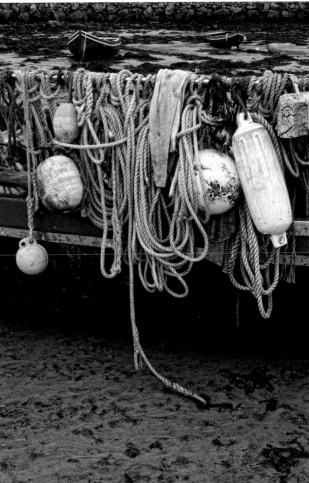

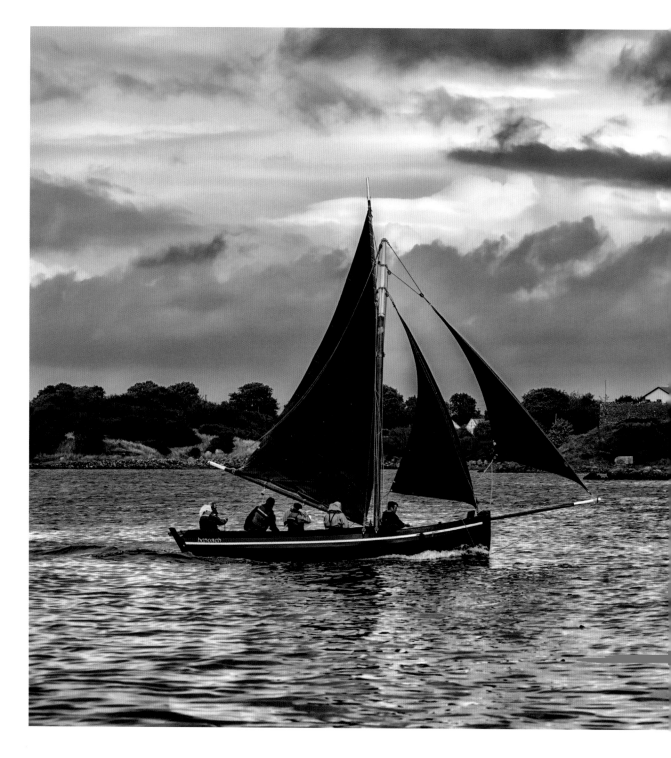

The Burren is a limestone karst landscape and doesn't fit the common conception of Ireland one bit. At first glance, the Burren is grey – grey limestone pavements, grey hills, grey drystone walls. *It is a country where there is not enough water to drown a man, wood enough to hang one, nor earth enough to bury him.* (English lieutenant-general Edmund Ludlow during his campaign in 1651/52). But this first impression couldn't be more wrong. Especially during the months of spring and summer, clusters of wildflowers paint the limestone desert in all the colours of the rainbow. These wildflowers, a unique combination of arctic, alpine and Mediterranean flowers, the dense accumulation of historic monuments and its strangely beautiful landscape, above and underground, have made the Burren justly famous.

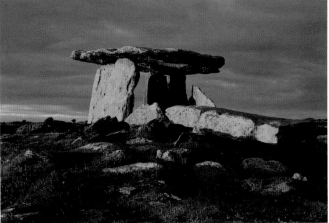

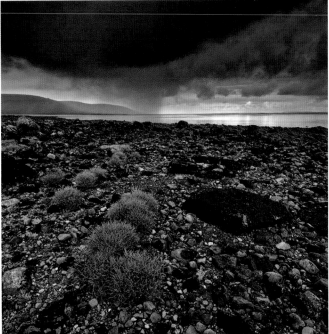

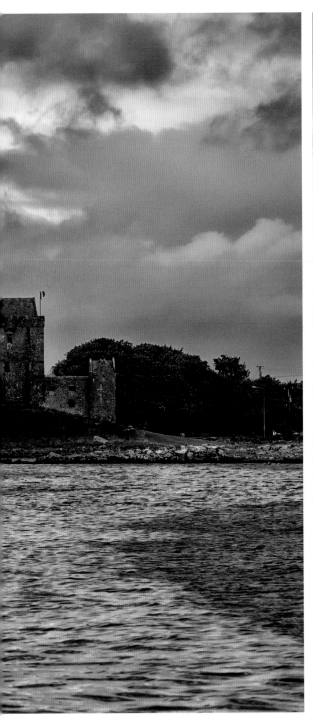

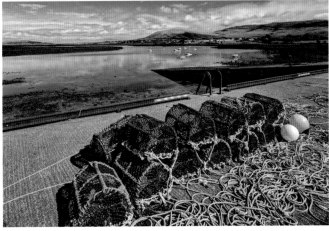

Left page: Galway Hooker – a traditional West of Ireland fishing boat – Kinvara, County Galway
Right page from top: The Poulnabrone Dolmen. This portal tomb in The Burren, County Clare dates from the Neolithic Period. Rain on the Burren, Bishopsquarter, The Burren, County Clare Ballyvaughan Pier, The Burren, County Clare.

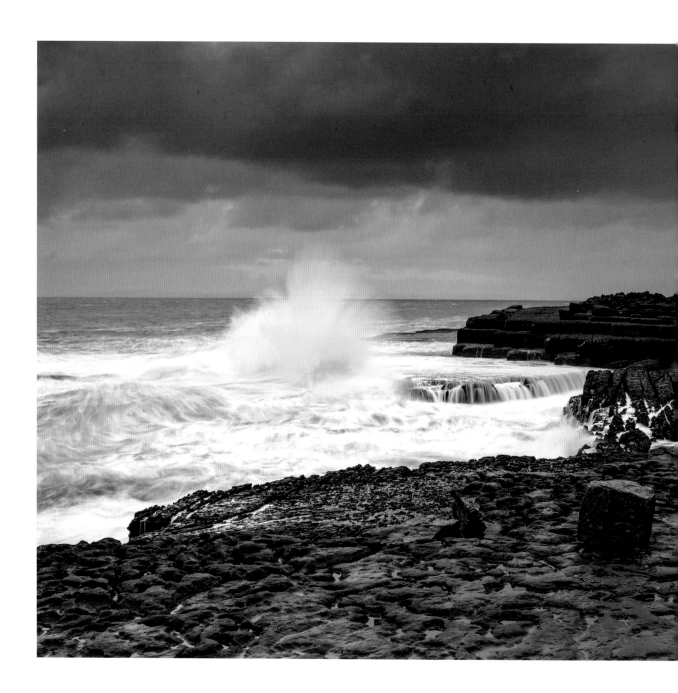

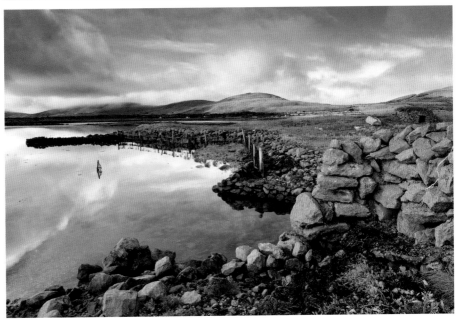

Left: Burren coast near Doolin, The Burren, County Clare
Top right: The Great Stalactite, Doolin Cave, The Burren, County Clare
Bottom right: Corranore Bay, The Burren, County Clare

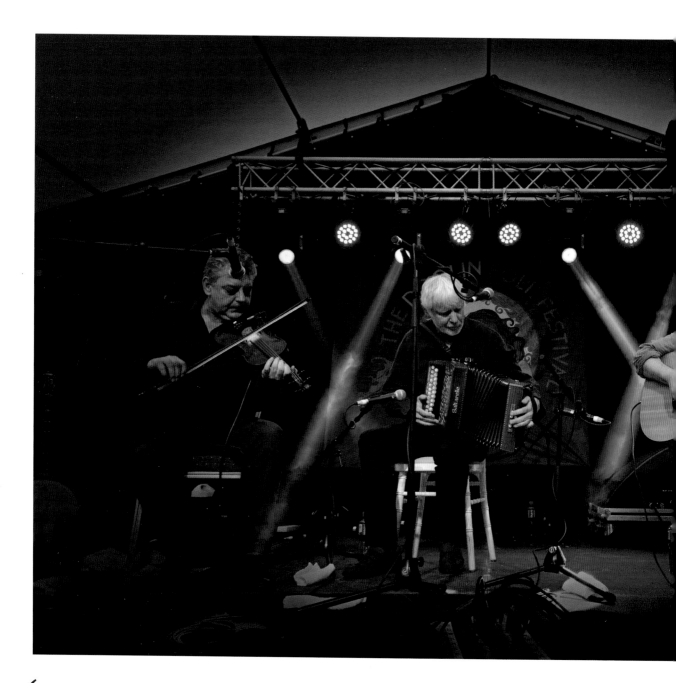

'I'd been puzzled for a few days. According to my map Doolin does not exist. I couldn't find it on any other map either. There is somewhere called Fisherstreet, and nearby another place called Roadford.'

Irish Shores, Paul Clements

Left page: The Martin O'Connor Trio at the Doolin Folk Festival
Right page top: MOXIE at the Doolin Folk Festival
Right page bottom: Pub session

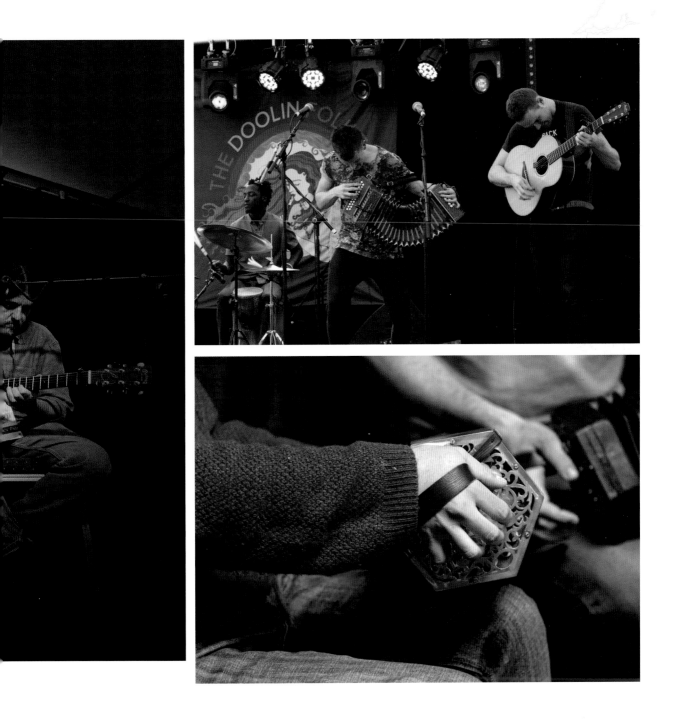

C lare has always been known for its music so it is no wonder that some of the biggest traditional music festivals are based in the Banner County. The Willie Clancy Summer School had been established in 1973 in memory of Milltown Malbay piper Willy Clancy. Each summer the small town becomes the hub of Irish traditional music with various workshops, concerts and impromptu sessions in the pubs and on the streets. The Doolin Folk Festival was first held in 2013 taking over the legacy of the legendary Lisdoonvarna Festival of the late 1970s and early 1980s and has quickly become a legend of its own.

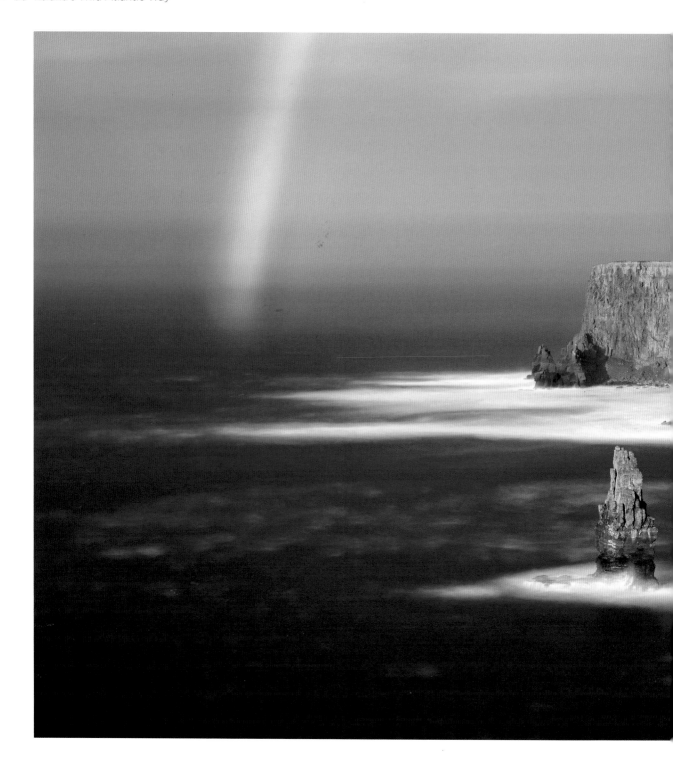

Left page: Cliffs of Moher, County Clare At 214 metres high and stretching along the coast for eight kilometres, these cliffs are Ireland's most visited natural attraction, and it's not hard to see why. On a clear day, the view out across the sea and to the islands has to be seen to be believed.
Right page top: Whitestrand, Milltown Malbay, County Clare
Right page bottom: Peadar Reilly of the Burren Smokehouse, Lisdoonvarna, The Burren, County Clare

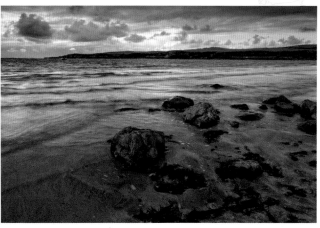

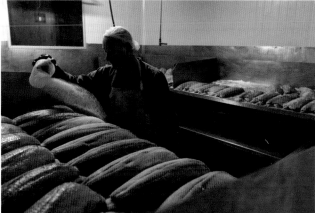

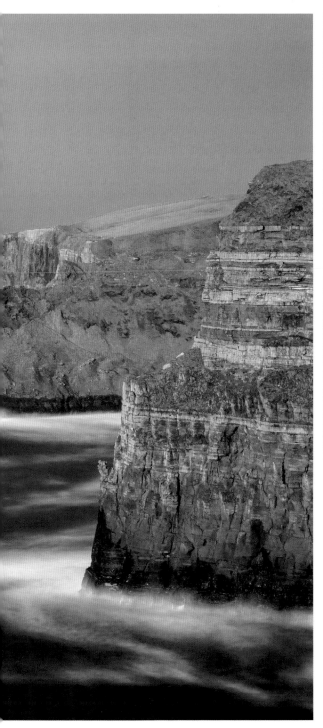

It probably is one of Ireland's last best-kept secrets: The Loop Head Peninsula. This narrow stretch of land is surrounded by the Atlantic Ocean to the north and the estuary of Ireland's longest river, the Shannon, to the south and has been described as 'the real Ireland'. It is windswept and wild with the smell of turf fire and salt in the air... it probably doesn't get more real than that.

The northern coast of the peninsula is dominated by some of the finest cliff sceneries in Ireland. The layers of rock twist and turn and have been shaped by the continuous onslaught of the ocean into sheer drops of more than 30 meters, sea stacks, islands and natural rock arches. The best of the latter is the Bridge of Ross, the last of former 3 natural bridges that stretches over a narrow channel. The other 2 bridges have collapsed many decades ago and only a painting by British artist W.H. Bartlett (1809-1854) gives an impression of what must have been a truly spellbinding sight.

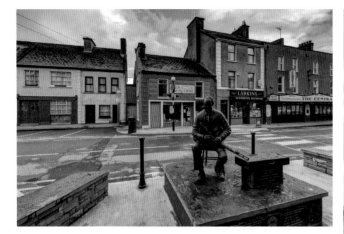

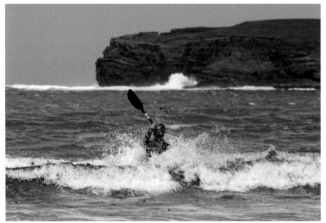

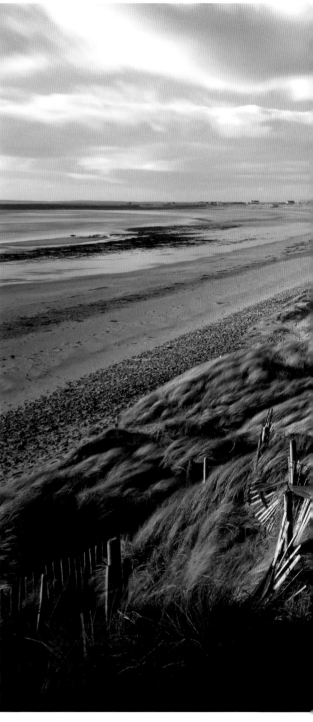

Left page top: Willy Clancy Memorial, Milltown Malbay, County Clare
Left page bottom: Sea Kayaking, Kilkee, County Clare
Right page: Doughmore Strand, Doonbeg, County Clare

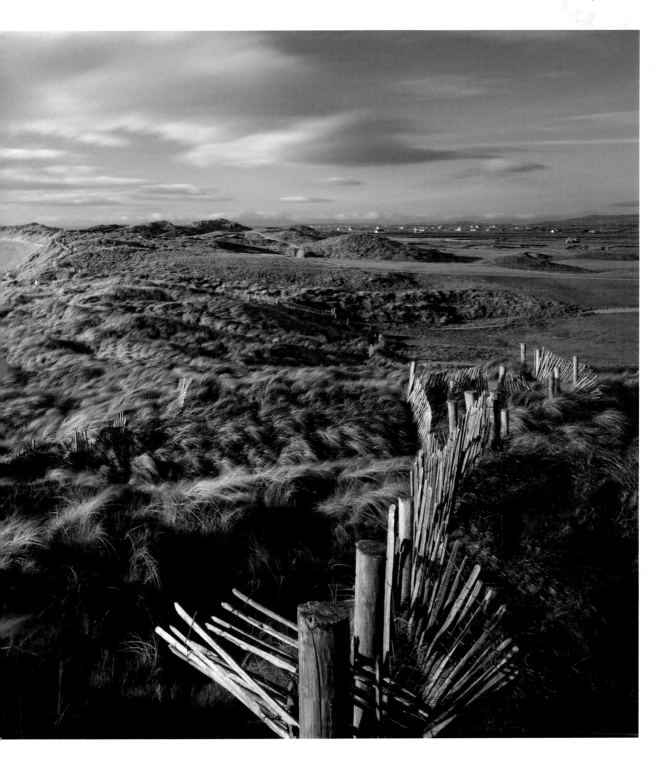

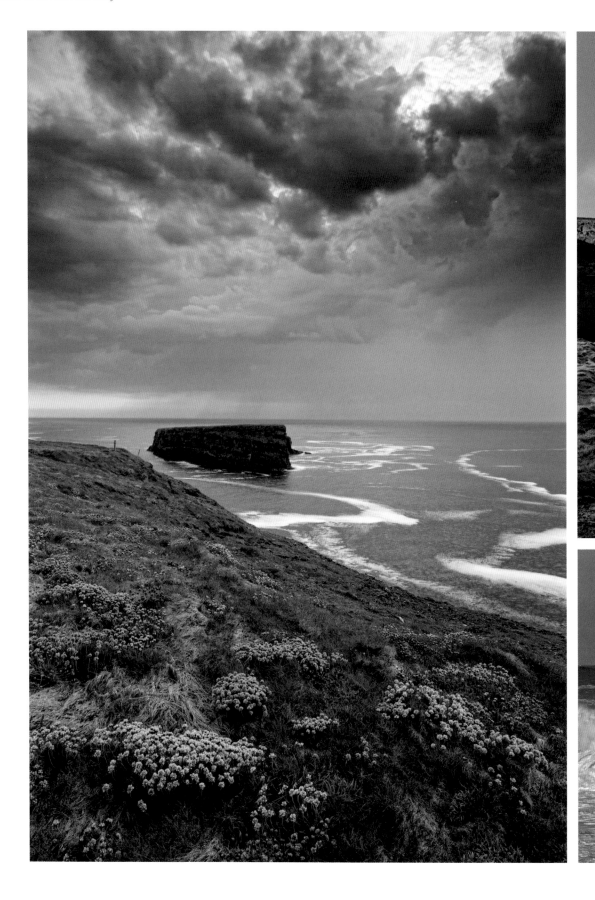

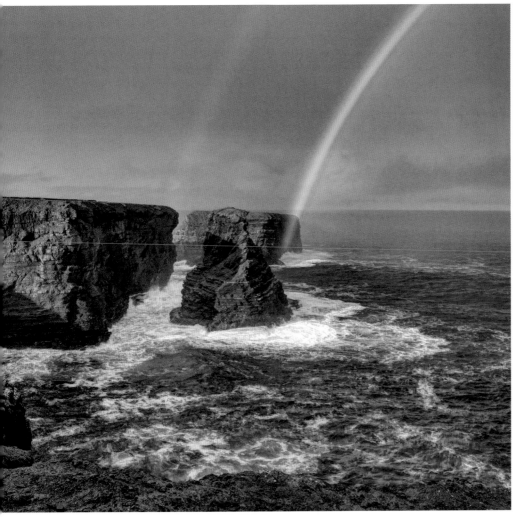

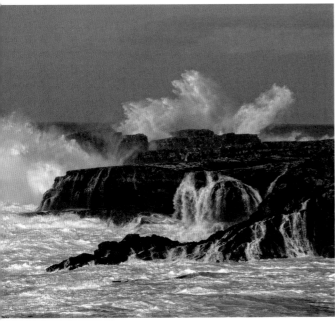

Left page: Castle Point, Loop Head Peninsula, County Clare
Right page top: Rainbows, Kilkee Coast Road, County Clare
Right page bottom: Ross, Loop Head Peninsula, County Clare

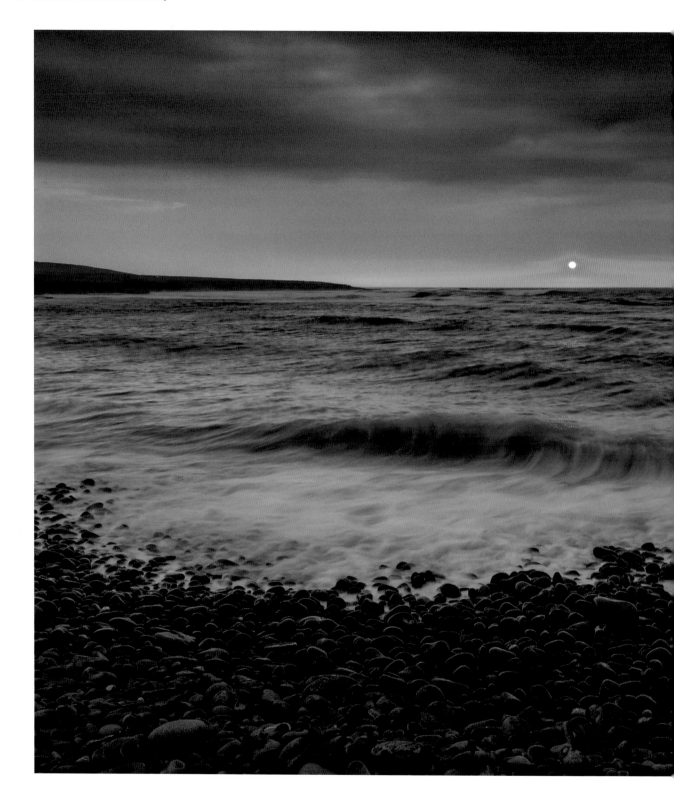

Left page: Fodry, Loop Head Peninsula, County Clare
Right page top: Rock Arch, Loop Head, County Clare
Right page bottom: Gull Island, Loop Head, County Clare

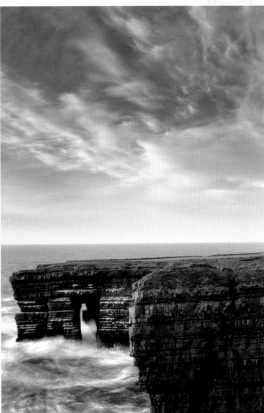

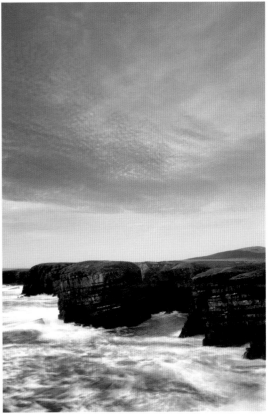

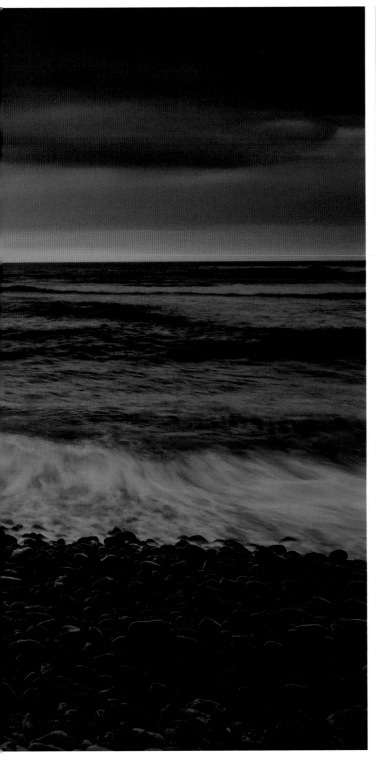

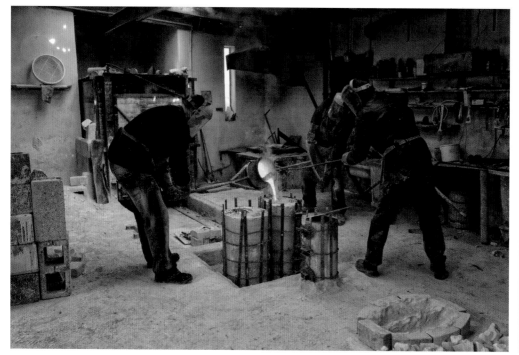

Left page: Seamus Connolly, Bronze Sculptor, Kilbaha, County Clare
Right page: Cliffs at Loop Head, County Clare

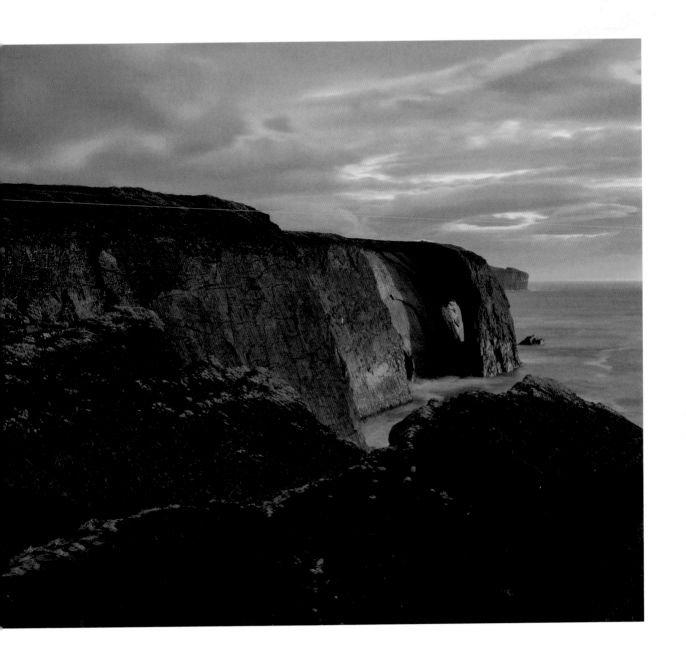

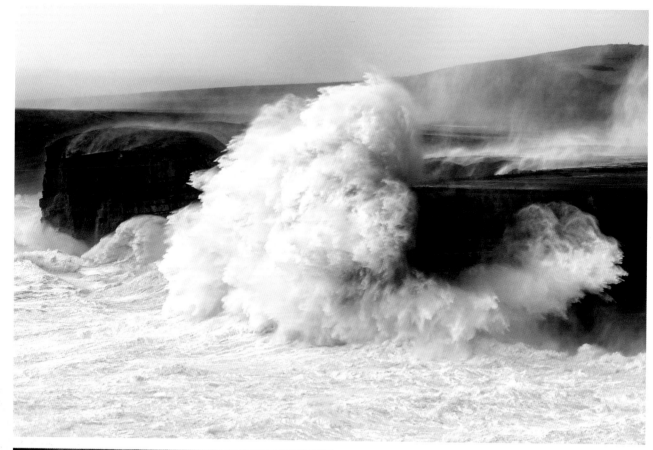

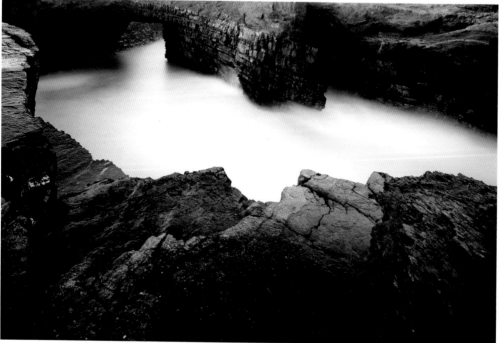

Top: St Brigid's Day Storm 2014, Loop Head, County Clare
Bottom: The Bridge of Ross, Loop Head Peninsula, County Clare

CLARE-KERRY

This part of the journey is so varied in its scenery and landscape that it's hard to believe it's all the one coastline. The first part leads along the quiet shores of the Shannon estuary and past the flat fields and vast sandy beaches of north Kerry. The second part navigates through the mountainous and busy (especially during the main tourist season) peninsulas of Dingle and Iveragh; the latter is probably better known as 'the Ring of Kerry'. Though the gentler stretches of the Shannon and North Kerry have a beauty all their own, it's easy to see why the Dingle and Iveragh peninsulas have become two of Ireland's major tourist attractions. The combination of a truly wild coastline consisting of sheer cliffs and sandy beaches and Ireland's highest mountain ranges acting as a backdrop is simply beautiful. Add the colourful villages that fulfill any romantic vision of Ireland and you have a winning combination. Despite the high number of visitors it isn't particularly difficult to find peace and quiet. Just leave the main roads and soon you will be all alone in a majestic mountain landscape.

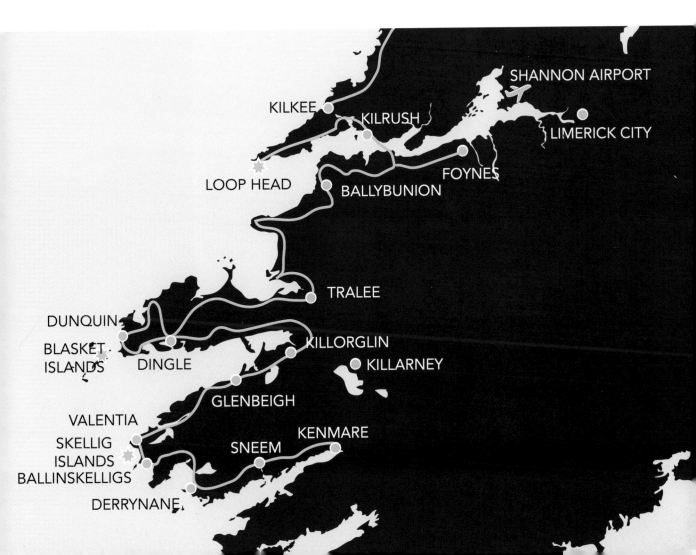

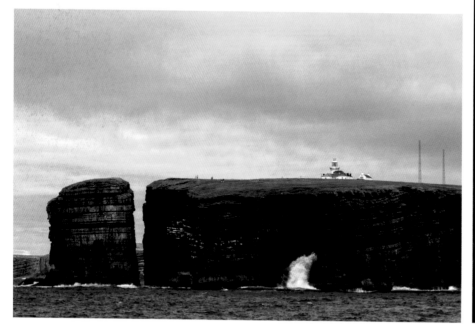

Left page: Loop Head with Diarmuid and Gráinne's Rock, County Clare
Right page: Loop Head Lighthouse, County Clare

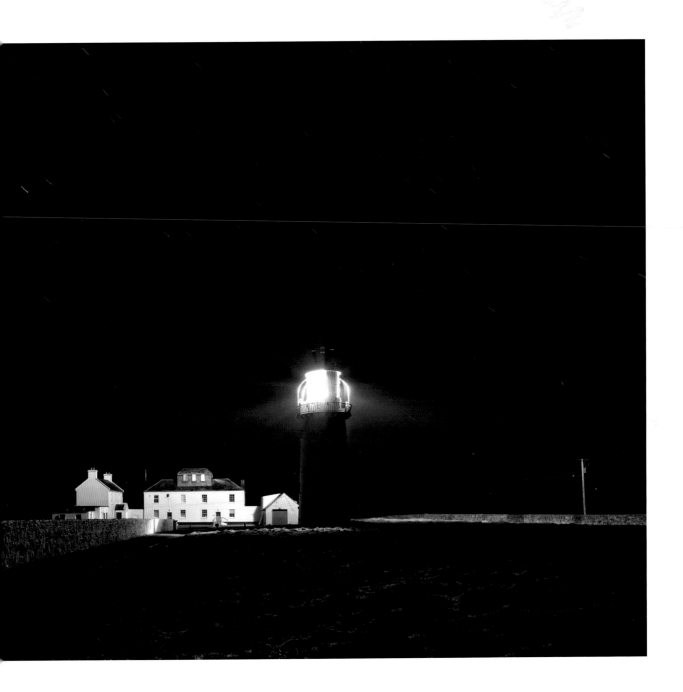

Diarmuid and Gráinne's rock, separated from the rest of the peninsula by a gap known as 'lovers' leap', is part of one of the great stories of Irish mythology' *Tóraíocht Dhiarmada agus Gráinne* (The Pursuit of Diarmuid and Gráinne). Gráinne, daughter of a high king of Ireland, was supposed to marry Fionn Mac Cumhaill, the legendary warrior and leader of the Fianna, but falls in love with one of his soldiers, Diarmuid, and runs away with him. A number of stories in various versions describe their flight across the country. In one version they arrive at Loop Head and in, order to escape the pursuing Fionn, the lovers leap over the narrow gap onto the rock. Fionn leaps after them. Diarmuid and Gráinne try to flee back to the mainland, but tragedy strikes' Diarmuid reaches the mainland with another big leap, but the exhausted Gráinne falls to her death. Looking down at the waves below, one can only imagine the desperation that drove the couple there.

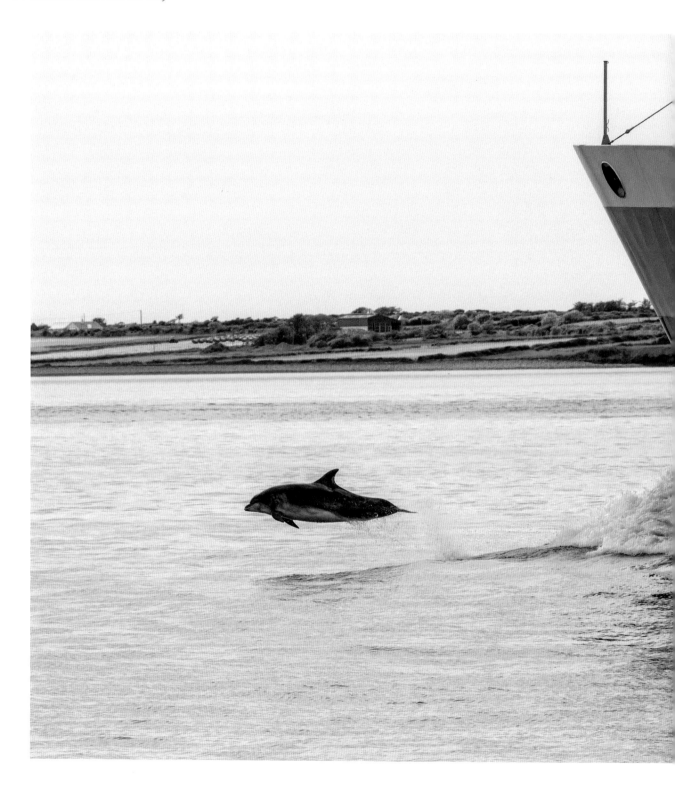

Left page: Bottlenose Dolphins at the Shannon Estuary, County Clare/County Kerry
Right page top: Dolphin Watching on the Shannon Estuary, County Clare/County Kerry
Right page bottom: Cliffs and Sea Caves, Loop Head Peninsula, County Clare

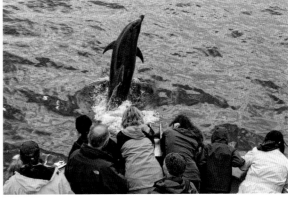

The estuary of the river Shannon is home to a group of more than a hundred resident Bottlenose Dolphins. The animals take advantage of the strong tidal flow in the estuary that brings a constant and rich food supply. During spring and summer regular boat trips leave from Kilrush and Carrigaholt for dolphin and nature watching trips, but the 'Shannon Dolphins' as they are locally known can also often be seen from the mainland.

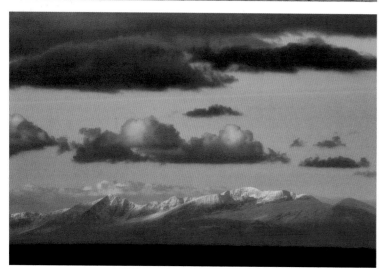

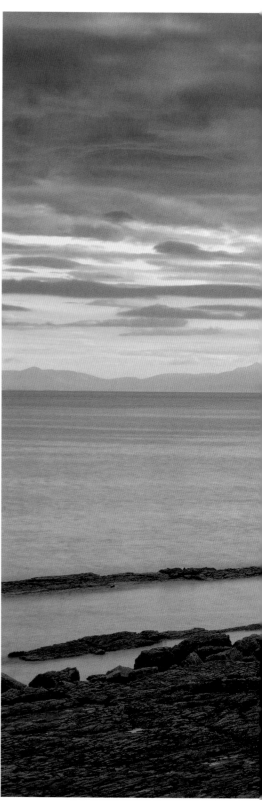

Left page top: Fishing Trawler on the Shannon Estuary, County Clare/County Kerry
Left page centre: Christmas the Wild Atlantic Way
Left page bottom: Kerry Mountains and Shannon Estuary

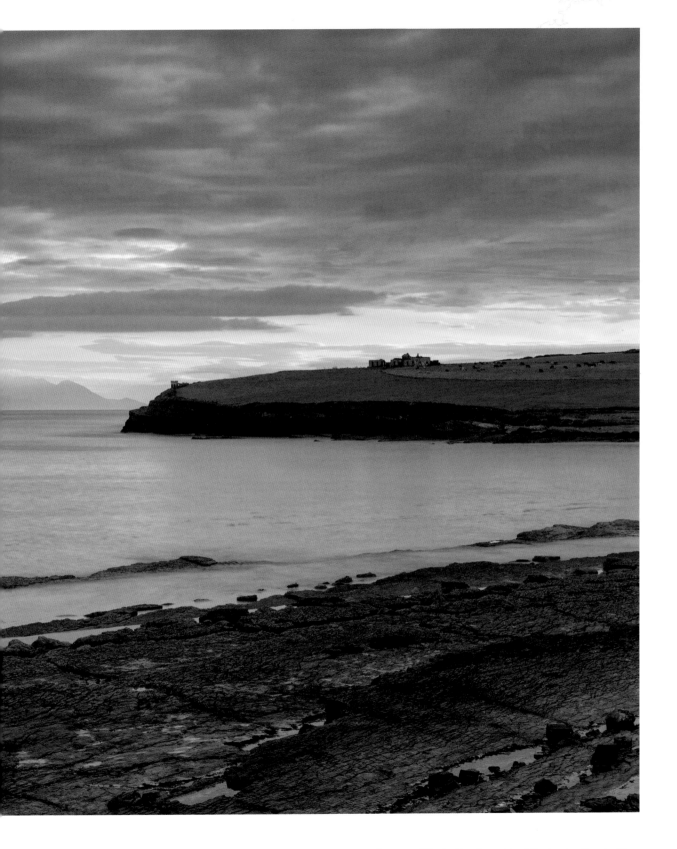

Right page: Kilbaha Bay, Loop Head Peninsula, County Clare

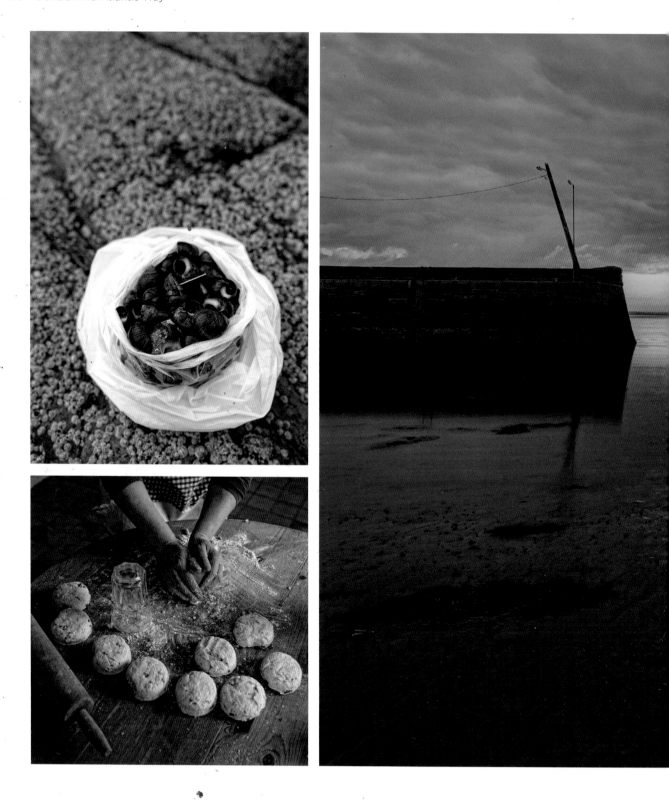

Left page top: Perriwinkles (sea snails and a local delicacy) Stand, Kilkee, County Clare
Left page bottom: Homemade Scones, Carrigaholt, County Clare
Right page: Carrigaholt Pier and Castle, Loop Head Peninsula, County Clare

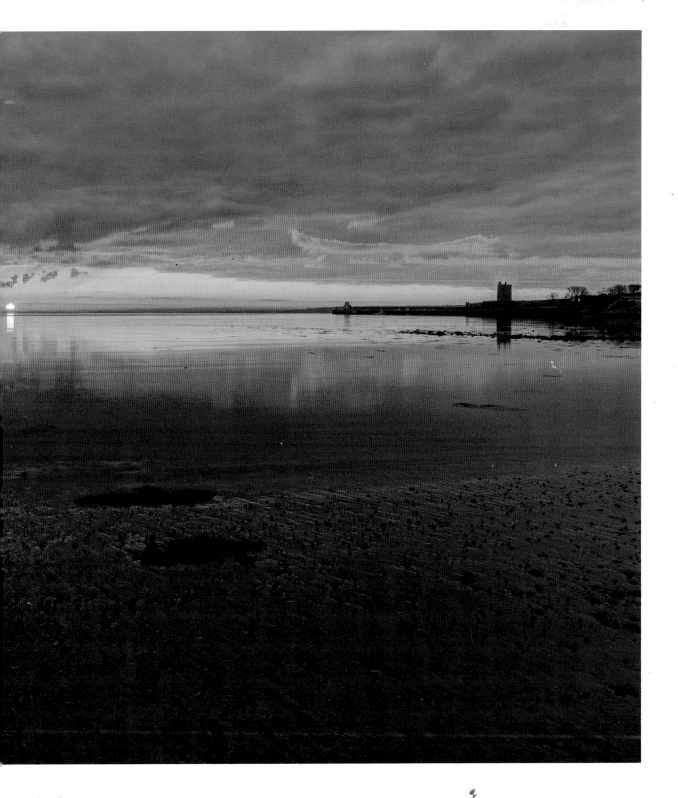

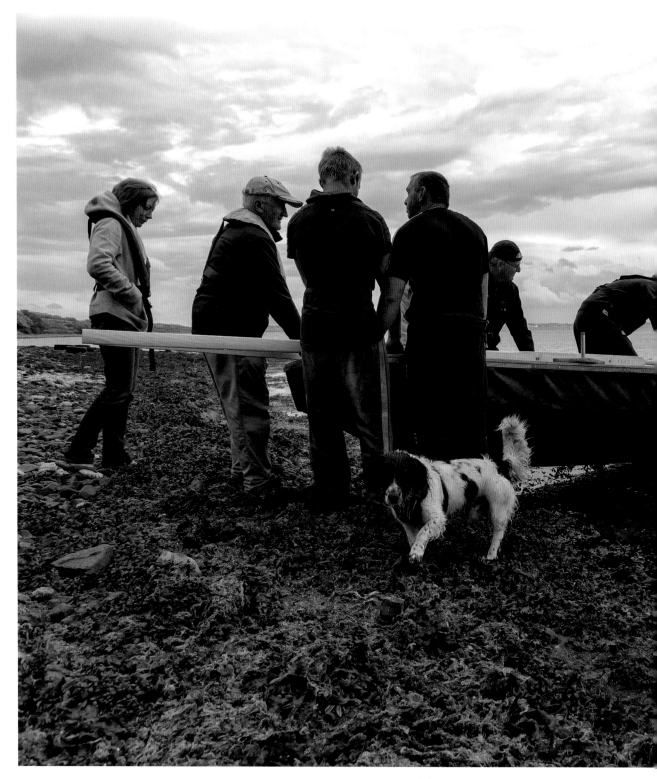

Left page: Loop Head Pilot Canoe, Querrin, County Clare
Right page top: Traditional sailing boat Sally O'Keeffe, Shannon Estuary, County Clare/County Kerry
Right page centre: The Street, Scattery Island, County Clare. Scattery Island lies in the Shannon Estuary just off the market town of Kilrush. It's best known for its monastic settlements, but was also home to a thriving community of fishermen. The main village was known as The Street. The last resident was relocated to the mainland in 1969.
Right page bottom: Cappa Pier, County Clare. Seaweed has being used as a fertiliser for centuries and this statue depicts a local fisherman/farmer, who still lives nearby, collecting seaweed.

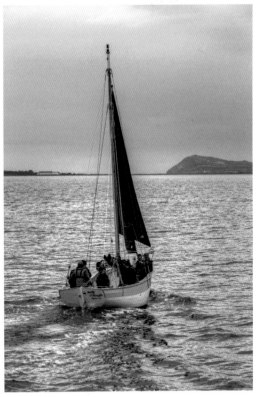

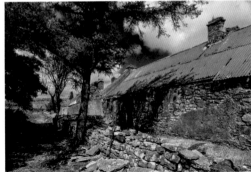

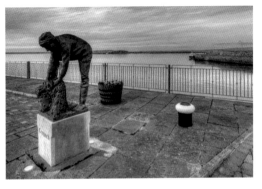

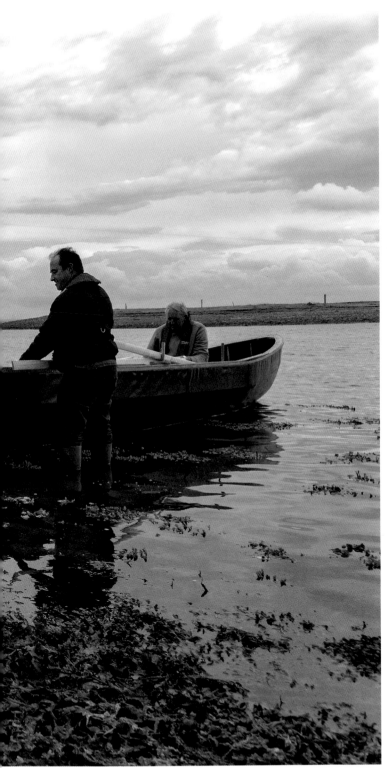

N earby is Kilrush, whence you can take boat to Scattery Island, a mile off shore, to visit all that is left of the monastery founded by St. Senan in the 6th century and still a place of resort for the pious. You will find the remains of six primitive buildings, churches or hermitages, and a fine round tower.' Robert Lloyd Praeger, *The Way That I Went*

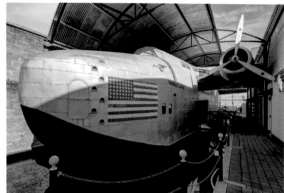

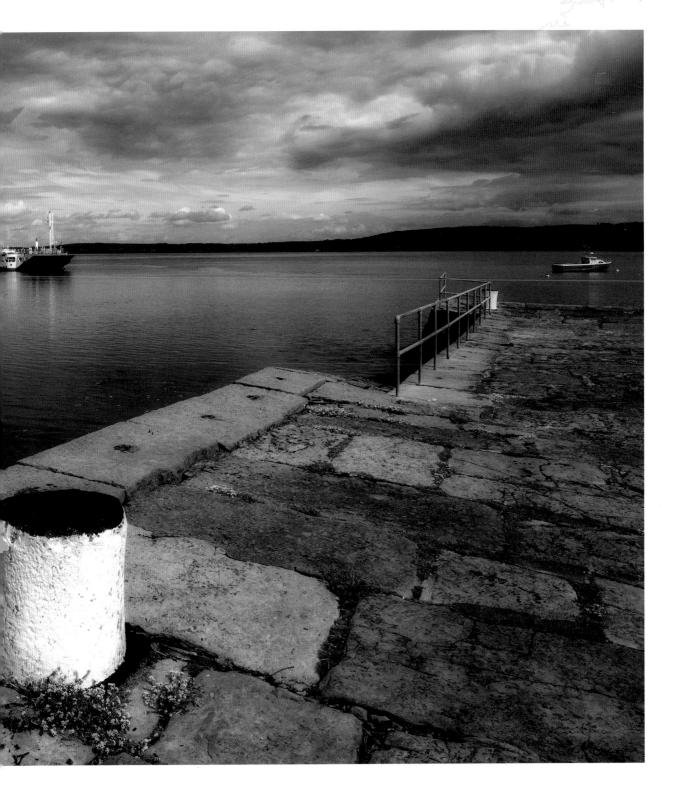

Left page: Flying Boat Museum, Foynes, County Limerick. This fascinating museum, Ireland's only aviation museum, is housed in the original terminal building in Foynes. The town was one of the central ports for flying boat aviation between 1937 to 1945.
Right page: Shannon Ferry is the quick link that brings travellers from Clare to Kerry. The crossing takes around twenty minutes and saves some 140 kilometres of travelling by road. Sailings are on an hourly (half hourly in the summer) basis and sometimes the Shannon Dolphins come along as well.

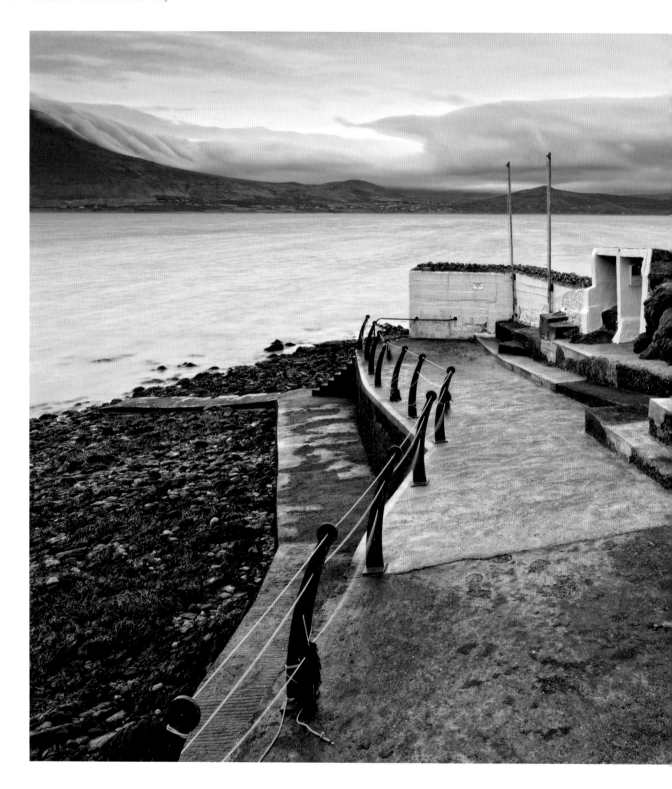

Left page: Fenit, Little Samphire Island and Dingle Mountains, County Kerry
Right page top: Walking the Dog, Ballybunion, County Kerry
Right page bottom: Ballybunion Strand and Castle, County Kerry

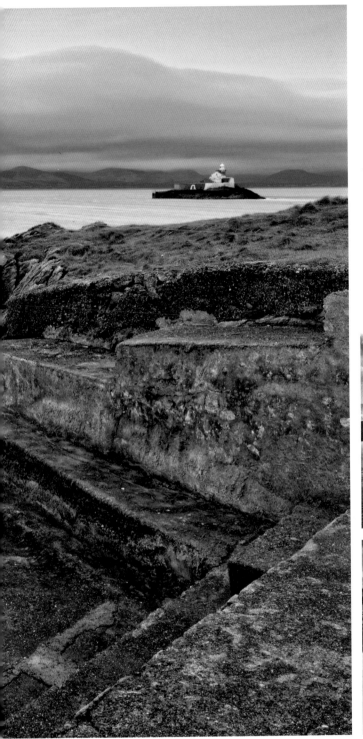

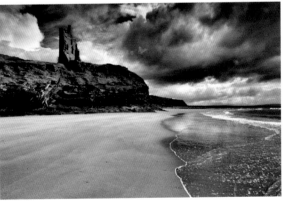

T he beaches along this stretch of Kerry coastline are beautiful in every type of weather; the interplay of wind, clouds, sea and sky has a wild magic all its own

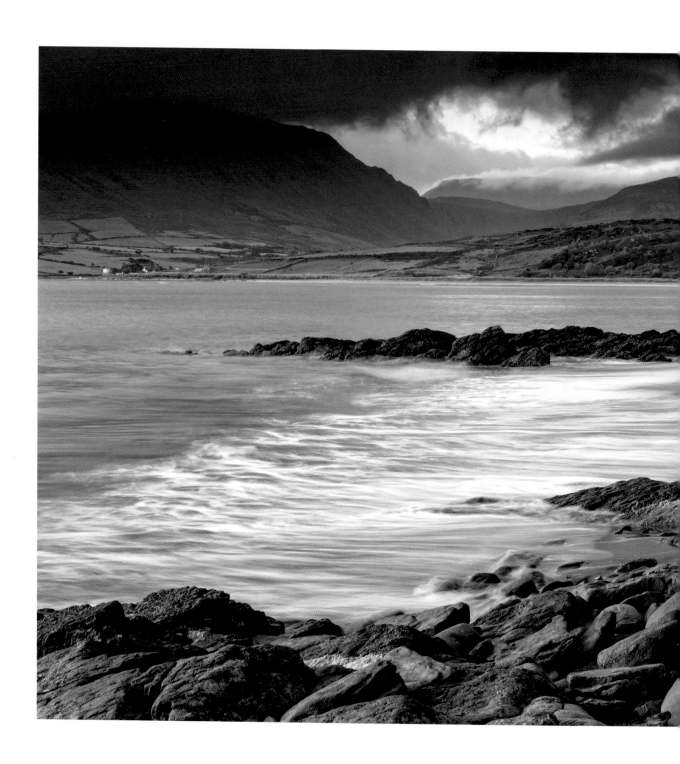

Left page: Brandon Bay, Dingle Peninsula, County Kerry
Right page top: The majestic beauty of the Conor Pass, Dingle Peninsula, County Kerry
Right page bottom: Glenteenassig, Dingle Peninsula, County Kerry

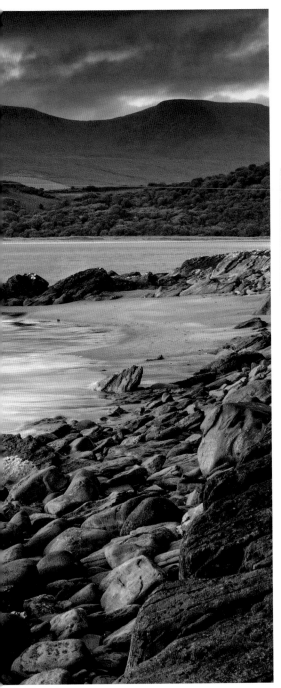

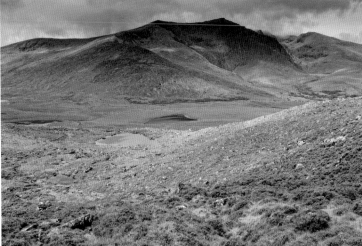

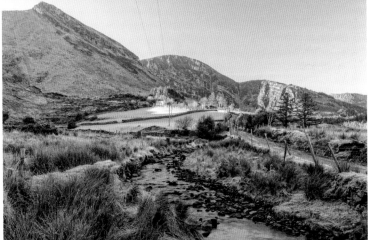

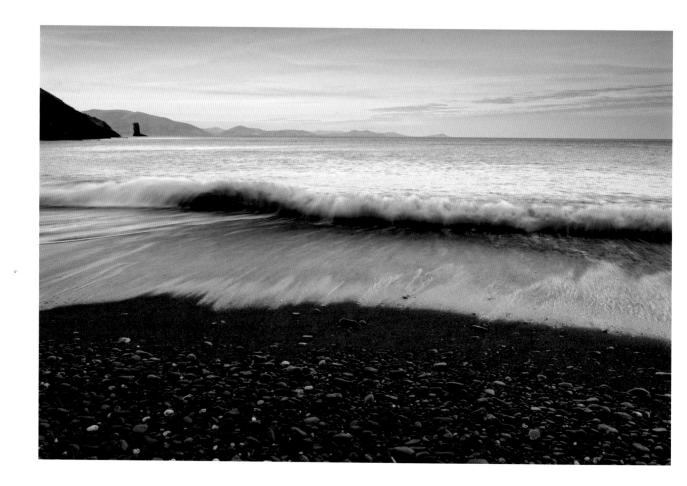

'I'm often seen in Ireland walking round with a permanent grin on my face. People think I'm mad and jump out of the way crossing themselves and dragging their children with them. I'm not mad; it's just for all its faults, and it has many, Dingle town is still, to me, one of the best places on God's earth.'

Mike Harding *Footloose in the West of Ireland*

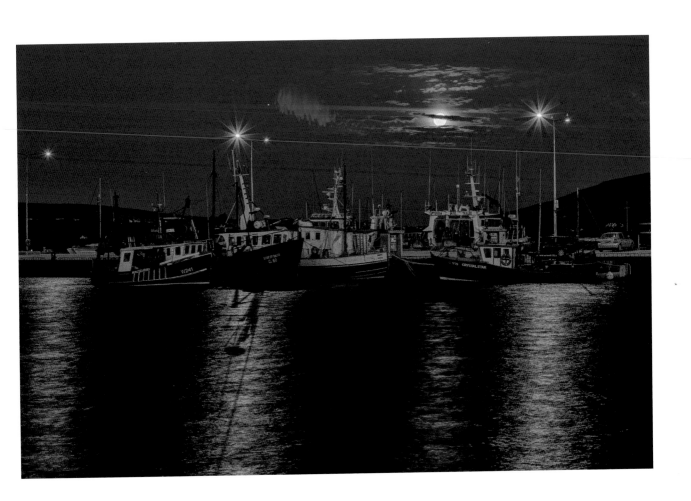

Left page: An Searrach, Dingle Peninsula, County Kerry
Right page: Full Moon over Dingle Harbour, Dingle, County Kerry

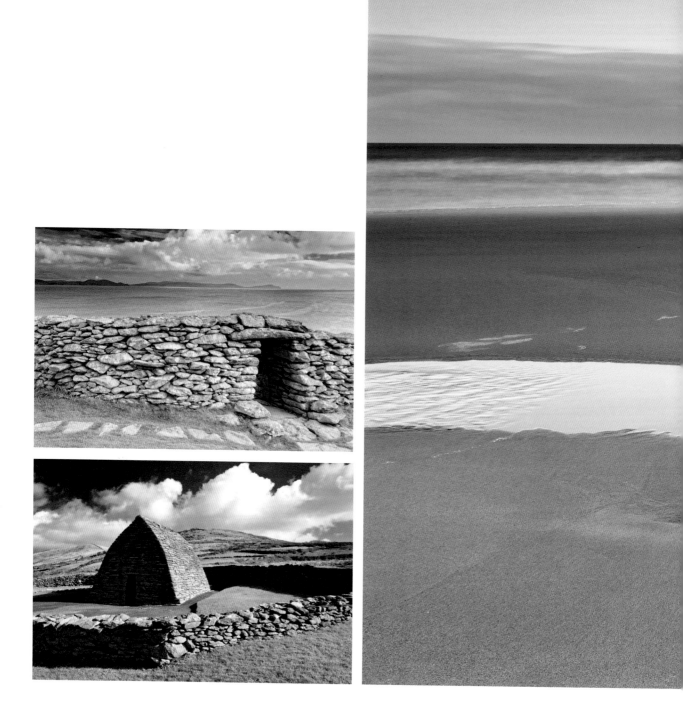

Left page top: Dunbeag Fort, Dingle Peninsula, County Kerry, which dates back to 500BC.
Left page bottom: Gallerus Oratory, Dingle Peninsula, County Kerry, believed to be an early Christian church.
Right page: Coumeenoole Bay, Dingle Peninsula, County Kerry

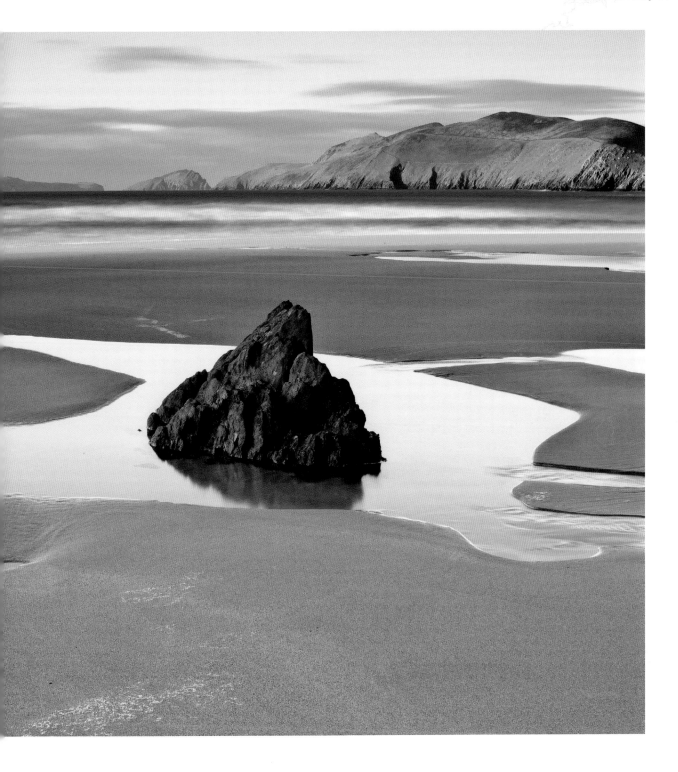

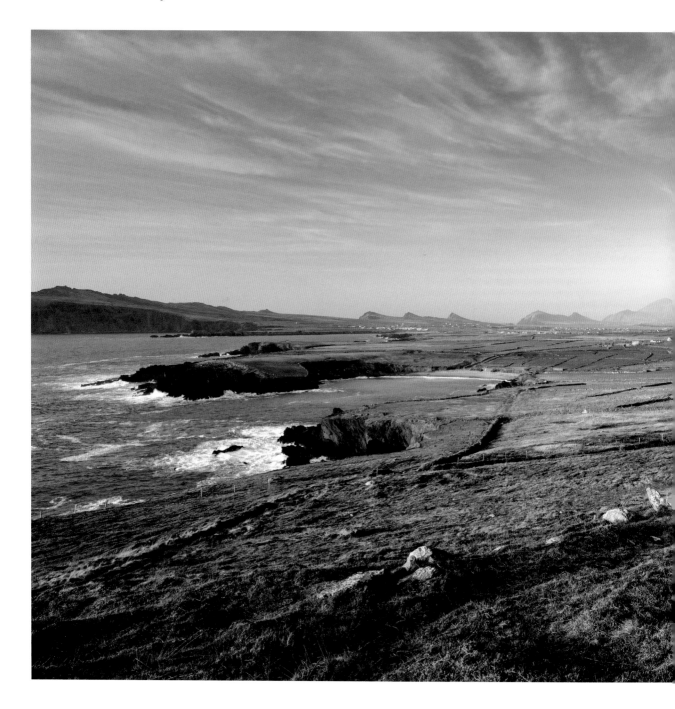

Left page: Clogher Strand with the Three Sisters in the background, Dingle Peninsula, County Kerry
Right page top: Potter Louis Mulcahy at work in his pottery, Clothar, Dingle Peninsula, County Kerry
Right page bottom: Kilmalkedar Church, Dingle Peninsula, County Kerry. Old Irish churches are always places of discovery but Kilmalkedar Church and the surrounding graveyard are a treasure chest for anybody with any interest in history. The church itself is from the twelfth century and features a Romanesque doorway, finials at the gables and blind arcading in the nave. Inside the church and on the grounds are several interesting stones and crosses: The Alphabet Stone which dates from the sixth century, a holed Ogham Stone ('ogham' is the earliest form of writing in Ireland), a sundial and a 2.5 meter high stone cross.

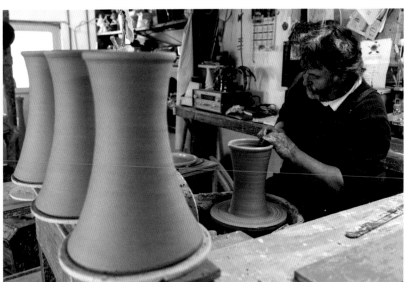

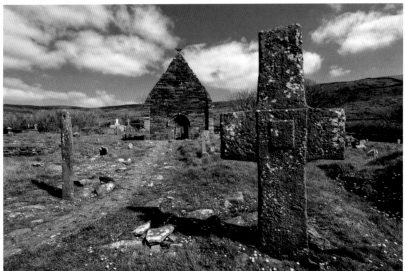

❝Kerry is mountain and ocean with a little bit of land in between.❞
Des Lavelle (Author, diver and fisherman)

Left page: O'Shea's Pub, Sneem, Iveragh Peninsula, County Kerry; an old-style pub in this colourful, friendly village.
Centre: The main street of Sneem, on the Iveragh Peninsula, County Kerry, with its brighty coloured houses.
Right page: Ross Behy Dunes, Iveragh Peninsula, County Kerry

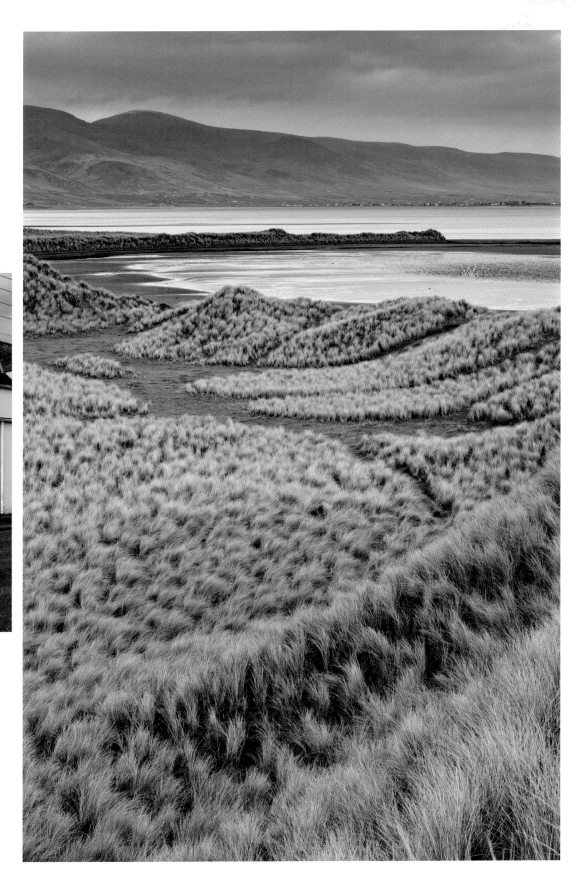

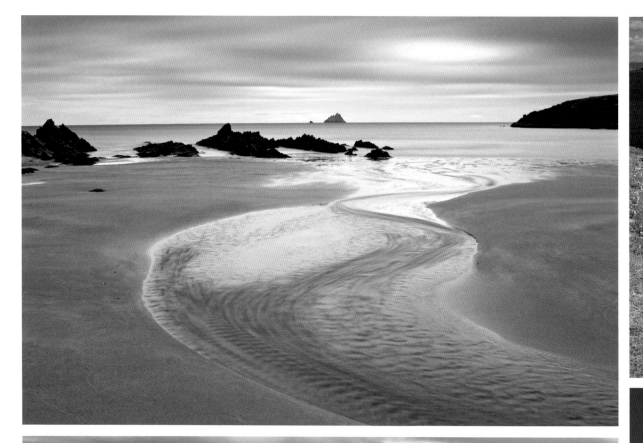

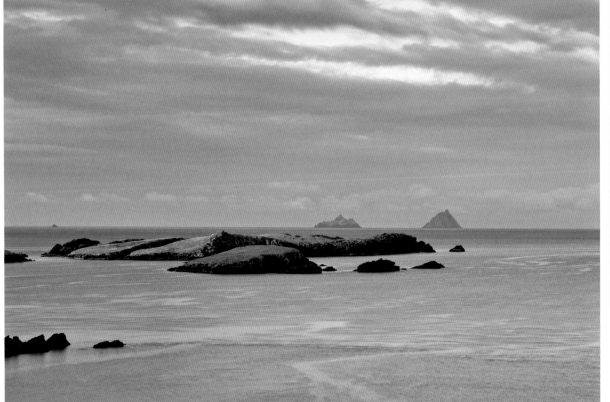

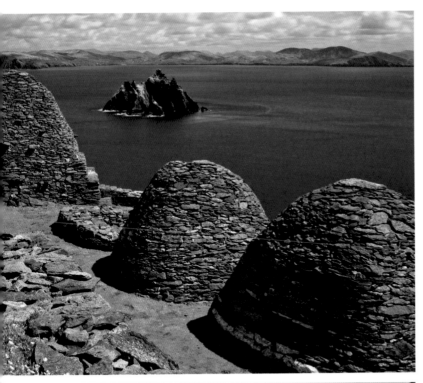

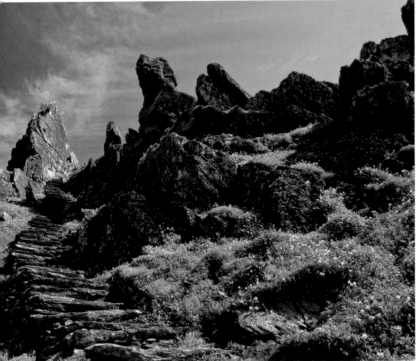

The Skelligs are not what you would expect from an island. They are rocky needles sticking out of the waters of the Atlantic, battered and beaten by wind and sea. The smaller one, Little Skellig, hosts one of Europe's biggest gannet colonies while the bigger island, Skellig Michael, is famous for its monastic settlement. This settlement consists of beehive huts, an oratory, a garden and burial ground, all towering more than 200 meters above sea level.

'... both the Skelligs are pinnacled, crocketed, spired, arched, caverned, minaretted; and these gothic extravagances are not curiosities of these islands: they are the islands: There is nothing else.'

George Bernard Shaw

Left page top: Saint Finan's Bay with the Skelligs in the distance, Iveragh Peninsula, County Kerry
Left page bottom: The Skelligs from Valentia Island, County Kerry
Right page top: Monastery on Skellig Michael, County Kerry
Right page bottom: The Steps, Skellig Michael, County Kerry

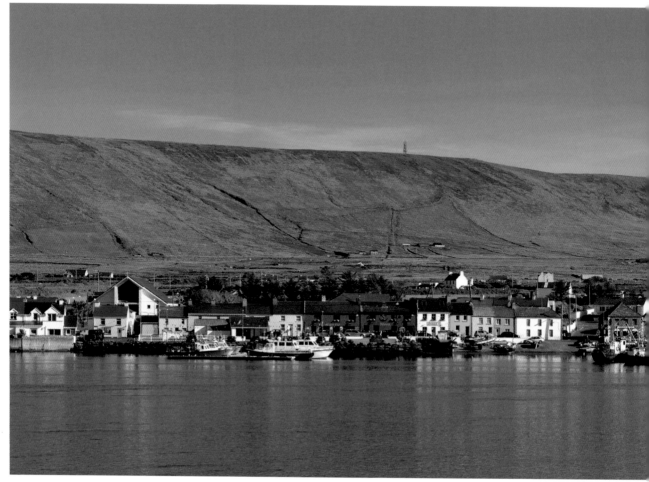

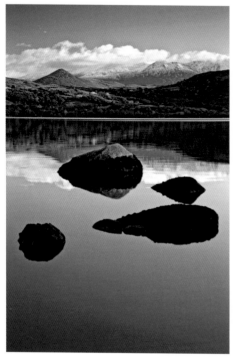

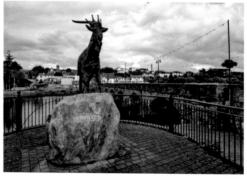

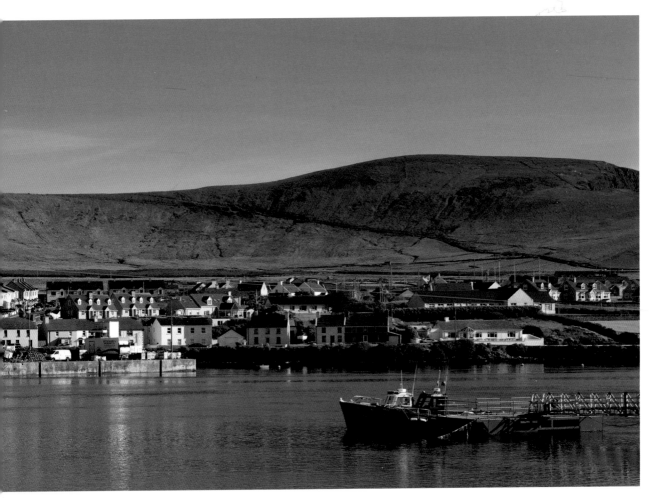

Top: Portmagee, Iveragh Peninsula, County Kerry

Left page left: The fairytale beauty of Lough Carragh, Iveragh Peninsula, County Kerry

Left page right top: Tetrapod Trackway, Valentia Island, County Kerry
These footprints in a remote corner of Valentia Island are a reminder of a very distant past and one of only four similar trackways in the world (there is one other in Scotland and two in Australia). These tracks have been made on what was probably the mud of a river estuary some 350 million years ago by a Tetrapod, a four legged amphibian, and represent the transition of life from water to land.

Left page right bottom: King Puck Statue, Killorglin, County Kerry. During the 400-year-old Puck Fair held every August, a wild mountain goat is captured, brought to the village and crowned as 'king' for three days.

Right page: Ballaghbeama Gap, Iveragh Peninsula, County Kerry

'*One day alone in Kerry, away from the roads on mountains that go down sharply to the sea; and you understand why in lonely places the Irish believe in Fairies and things not of this earth.* '
H.V. Morton '*In Search of Ireland*'

Left page: Fog on Cummenduff Lough, County Kerry
Right page top: MacGillycuddy's Reeks from Ballaghisheen Pass, Iveragh Peninsula, County Kerry
Right page centre: Summer Haze at the Ring of Kerry, Illauncrone, Iveragh Peninsula, County Kerry
Right page bottom: Derrynane House, Iveragh Peninsula, County Kerry. Once home to nineteenth-century politician Daniel O'Connell, known as 'The Liberator', Derrynane House is now an Irish National Monument managed by the Office of Public Works, set in hundreds of acres of national park. In this beautiful setting visitors can learn about the life and career of one of Ireland' most famous politicians.

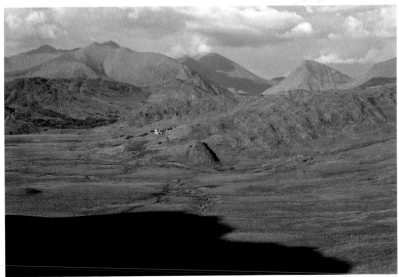

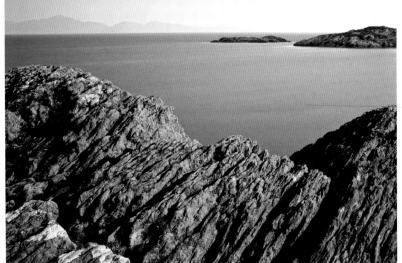

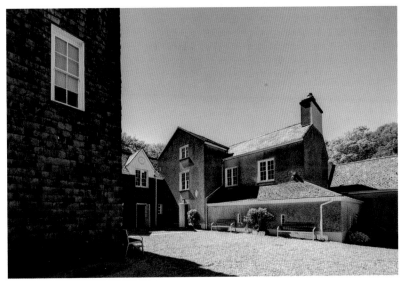

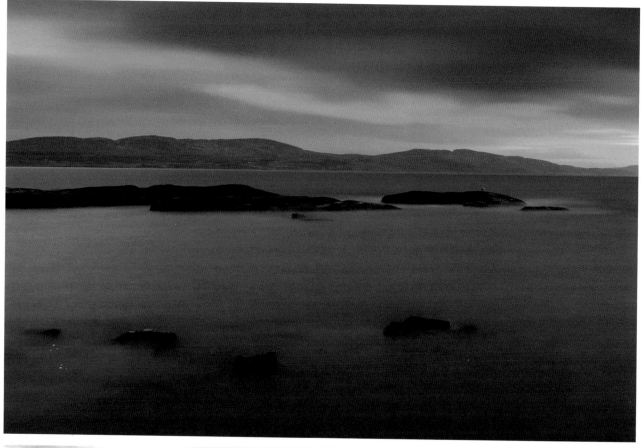

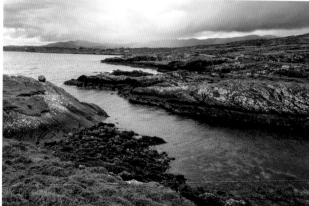

Top: Dusk at Kenmara River, Iveragh Peninsula, County Kerry
Bottom left: Gleesk Harbour, Iveragh Peninsula, County Kerry
Bottom right: Rocks and Shed, Gleesk, Iveragh Peninsula, County Kerry

KERRY-CORK

The last leg of the Wild Atlantic Way leads along the southwestern shores that are Ireland's version of the Mediterranean. Especially during spring and summer the first word that comes to mind when looking at the landscape is 'lush'; the early part of this trip leads along the peninsulas of Iveragh, Sheep's Head and Mizen and at the eastern ends of these promontories the vegetation is more reminiscent of a Mediterranean or even tropical island than of the windswept shores of Ireland. Native oak and beech woodlands intermingle with the invasive rhododendron and even more exotic species like myrtle trees and tree ferns thrive in the sheltered bays around Bantry, Glengarriff and Kenmare. Further out west the scenery becomes ever more dramatic, with sheer cliffs and sandy beaches.

The second part of this stretch follows the southern coast of County Cork from Skibbereen to Kinsale. This stretch of coast is a mixture of sheltered coves and wide sandy beaches. It takes some time to explore all the quiet back roads, but is more than worth it.

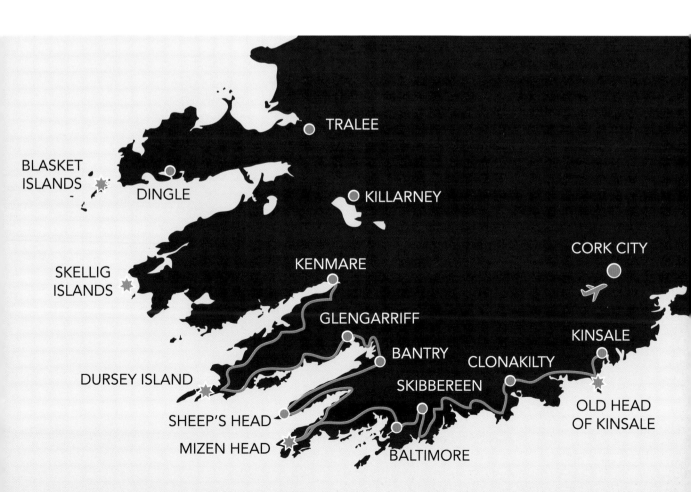

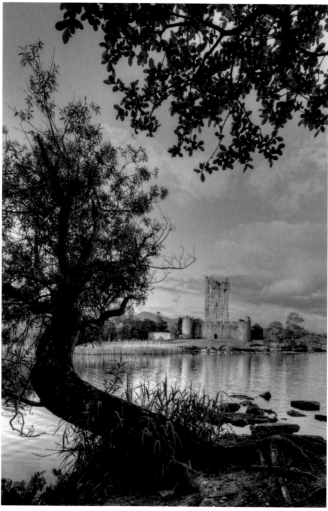

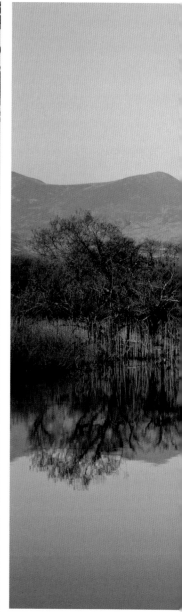

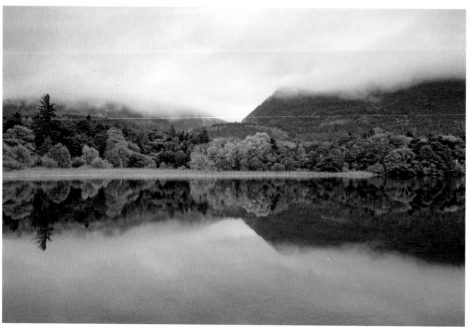

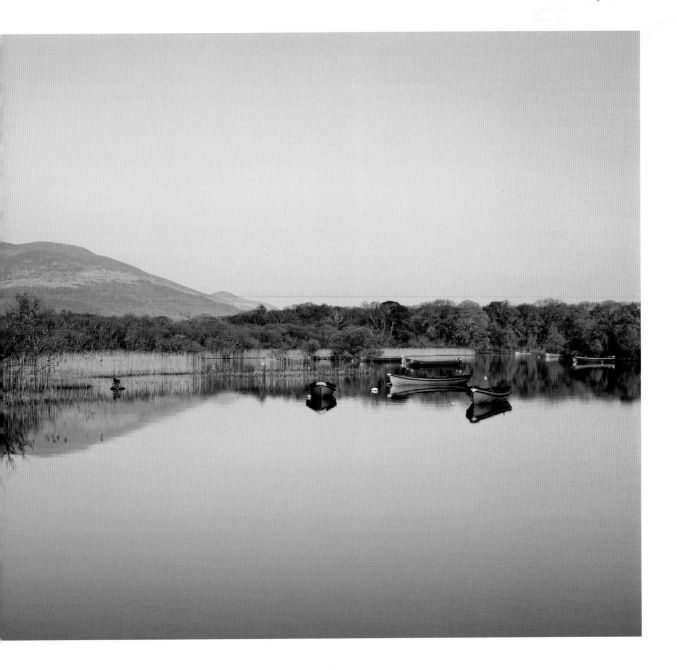

Killarney National Park, Ireland's oldest national park, was created in 1932 when Muckross Estate was donated to the Irish state. Today the park stretches over more than 100,000 square kilometers of various habitats and diverse ecology. The Lakes of Killarney, rare oak and yew woodlands and Ireland's only native herd of red deer are the most precious parts of the park. Many places within the boundaries of Killarney National Park have become known around the world like the Gap of Dunloe, Ladies View, Torc Waterfall and the Meeting of the Waters.

In the heart of the park stands Muckross House, a nineteenth-century Victorian mansion, which was built for Henry Arthur Herbert and his wife Mary Balfour Herbert, a well-respected water colourist. The house and its surroundings seem to have escaped from a period movie and it's no wonder that Muckross House and Gardens attracts thousands of visitors every year. Surprisingly it never seems (too) crowded even at the busiest of times and many signposted walks (and some unmarked paths) make it relatively easy to find solitude in the fairytale land of the Killarney National Park.

Left page top: Ross Castle, Killarney National Park, County Kerry
Left page bottom: Muckross Lake, Killarney National Park, County Kerry
Right page: Lough Leane, Killarney National Park, County Kerry

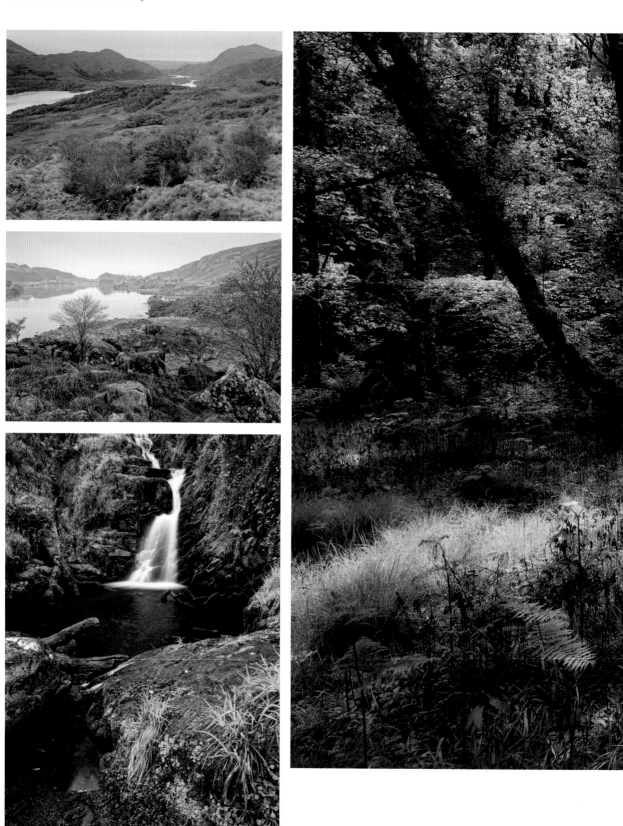

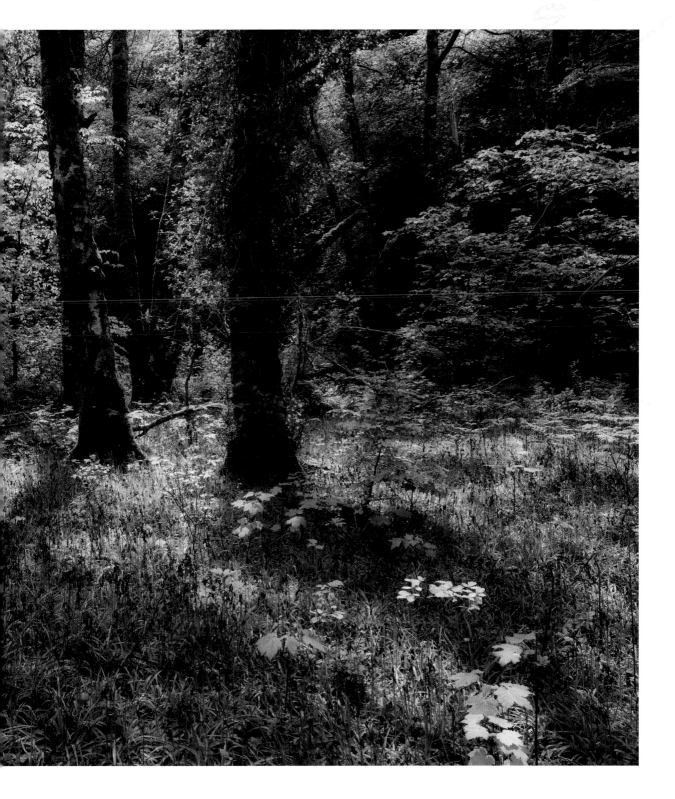

Left page top: Ladies View, Killarney National Park, County Kerry
Left page centre: Lough Looscaunagh, Killarney National Park, County Kerry
Left page bottom: O'Sullivan's Cascade, Killarney National Park, County Kerry
Right page: Bluebells, Killarney National Park, County Kerry

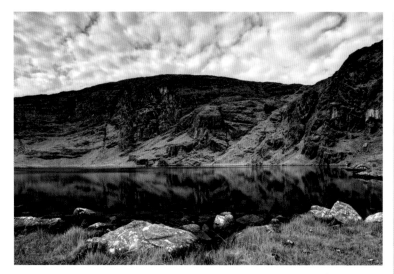

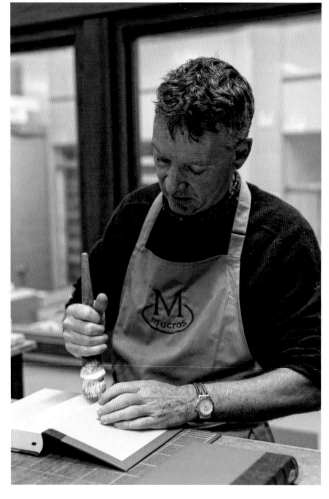

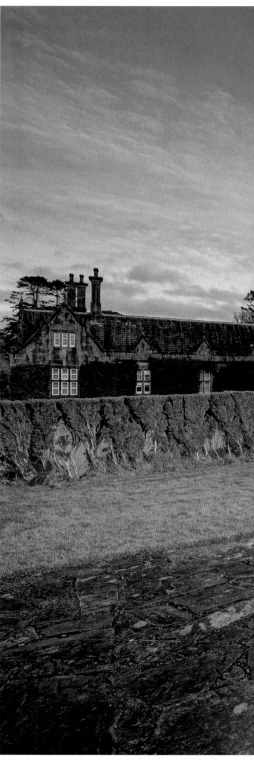

Left page top: Cummeendillure Lough, Beara Peninsula, County Kerry
Left page bottom: Conservation Bookbinder Paul Curtis of the Muckross Bindery, Killarney National Park, County Kerry
Right page: Muckross House, Killarney National Park, County Kerry

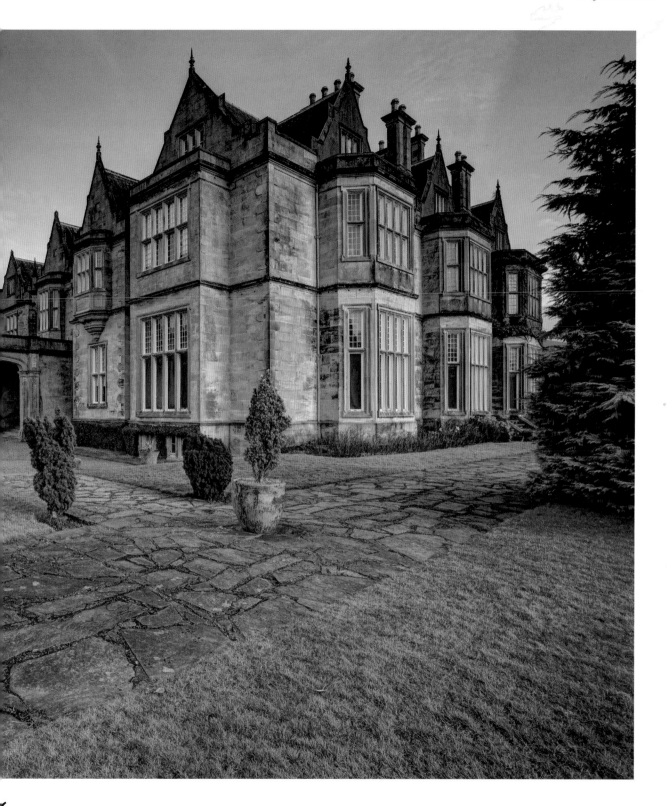

'The solitude is death like. There is no sound but the cries of wild birds and the bleating of black-faced sheep. There is no movement but the clouds which steam gently over the crests of the mountains.'

H.V. Morton, *In Search of Ireland*

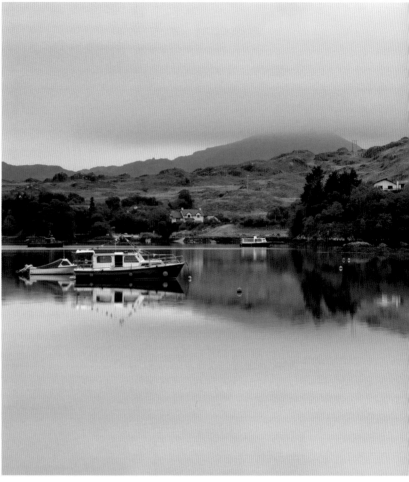

The Beara peninsula straddles counties Kerry and Cork and is as rich in history and archaeology as it is scenic. Travelling along its coastline, the visitor will encounter ancient stone circles and wedge graves, Ireland's only cable car and oldest oak forest, as well as beaches, lakes and mountains.

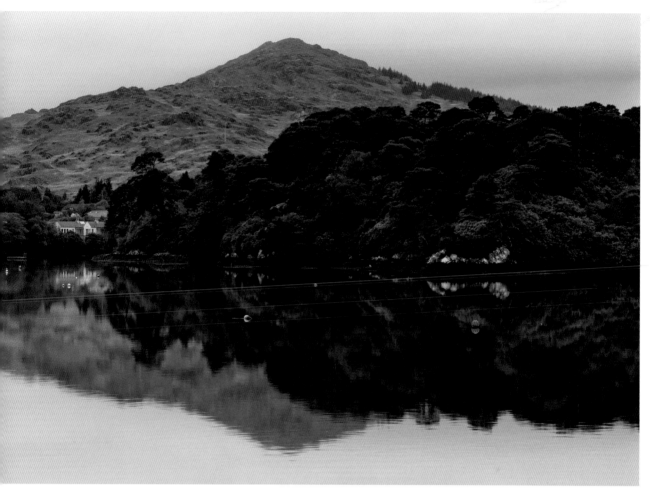

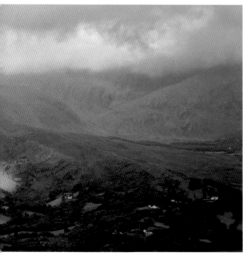

'... to Glengarriff, consisting of several large hotels and a few other houses. It stands at the extremity of a fairy-like-island-studded bay, facing full south, very sheltered, almost frostless in winter, seldom too hot in summer (though the midges might be pesky), embowered in native oak woods and semi tropical shrubs.'
Robert Lloyd Praeger, *The Way that I went*

Left page top: Canrooska River, Glengarriff Nature Reserve, Beara Peninsula, County Cork
Left page bottom: A restored 'cabin' in Gleninchaquin Park, Beara Peninsula, County Kerry. This would have been a typical dwelling in eighteenth-century Kerry. This park allows visitors to learn more about the history, landscape, flora and fauna of the valley.
Right page top: Glengarriff Harbour, Beara Peninsula, County Cork
Right page bottom: View from Caha Pass, Beara Peninsula, County Cork

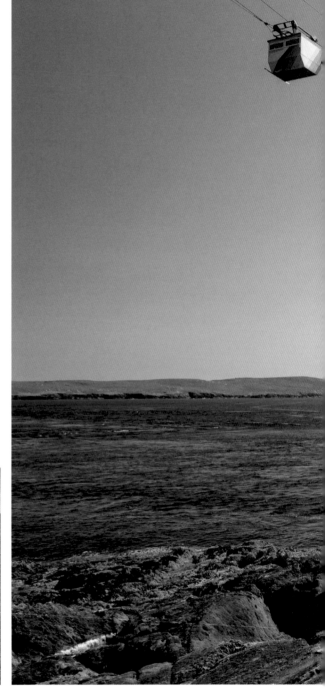

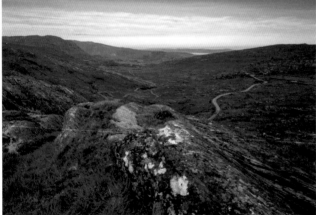

Left page: Healy Pass, Beara Peninsula, County Cork
Right page: Dursey Island Cable Car, Beara Peninsula, County Cork

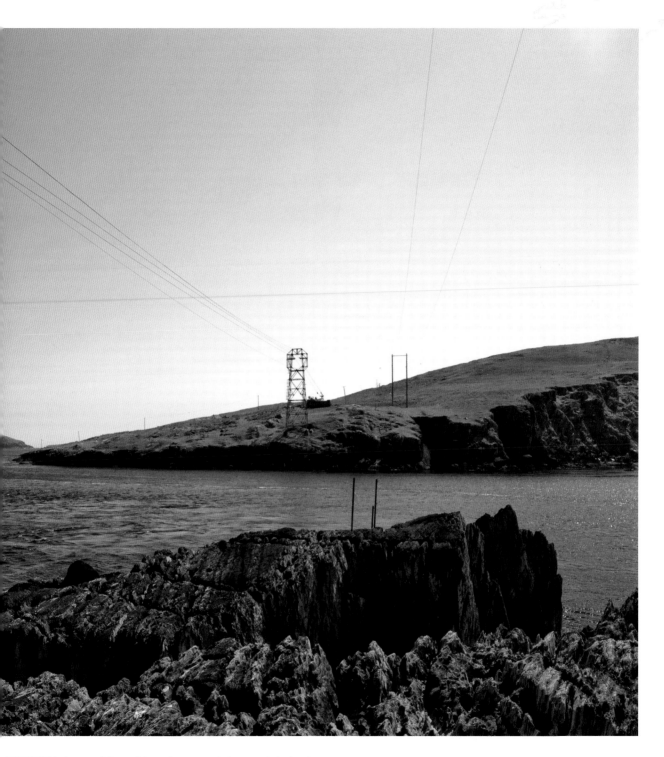

This is one of those things that can only happen in Ireland. Usually, if you want to go to an island you take a boat – at least that's what you'd think. But if you want to visit Dursey Island off the tip of the Beara Peninsula you can take a cable car to cross the turbulent waters of Dursey Sound. The cable car was established in 1969 and since then has transported men, women, children and sheep to and from the island. Unfortunately a few years ago sheep have been banned from travelling on the cable car, health and safety they say …

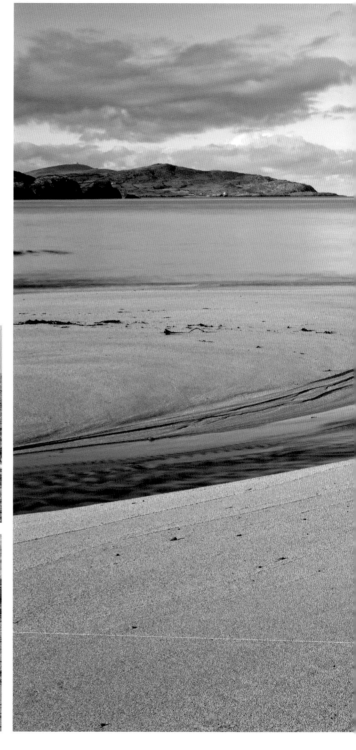

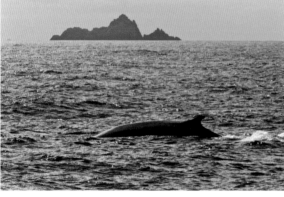

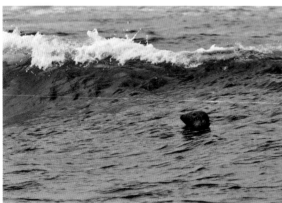

Left page top: Fin whale off the Skelligs, County Kerry. The waters of the south and south west of Ireland are regularly visited by whales: Fin and humpback whales are a common sight during late summer and autumn and even killer and blue whales have been spotted. Weather depending trips leave from Union Hall and Baltimore in County Cork and Ventry in County Kerry.
Left page bottom: Grey seal off Castle Haven, County Cork
Right page: Ballydonegan Strand, Beara Peninsula, County Cork

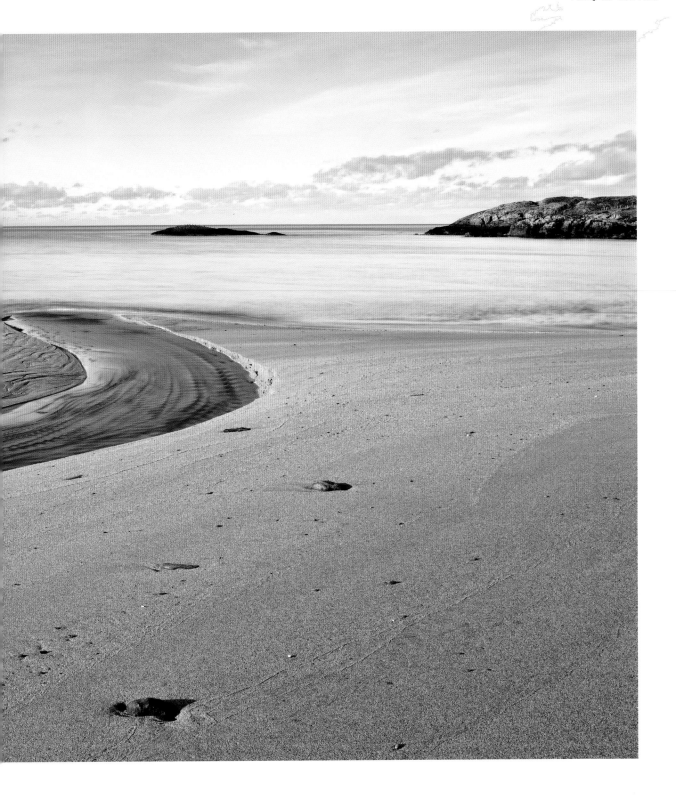

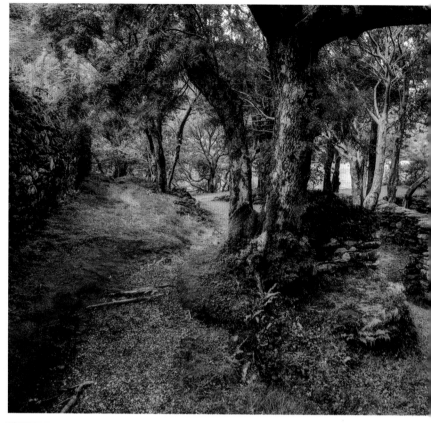

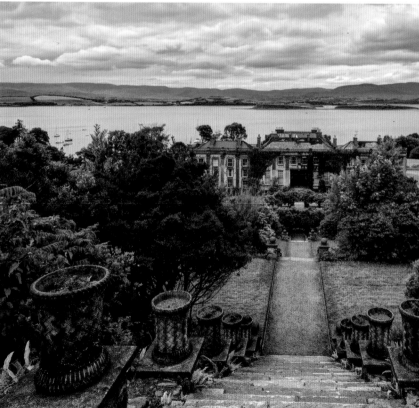

Left page top: Gougane Barra,
County Cork.
Left page bottom: Bantry House,
County Cork
Right page: Gougane Barra Church,
County Cork.

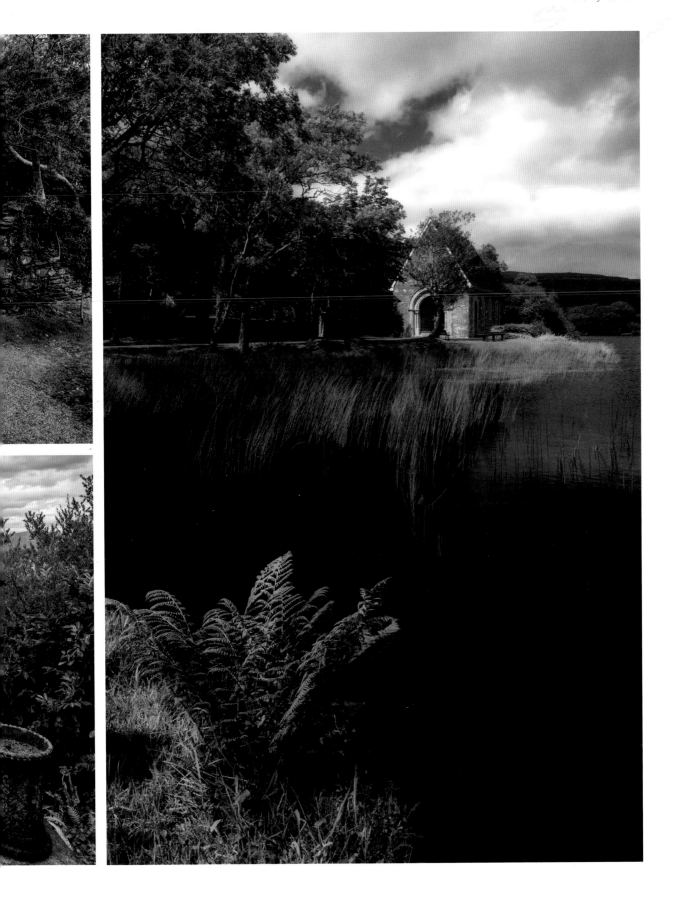

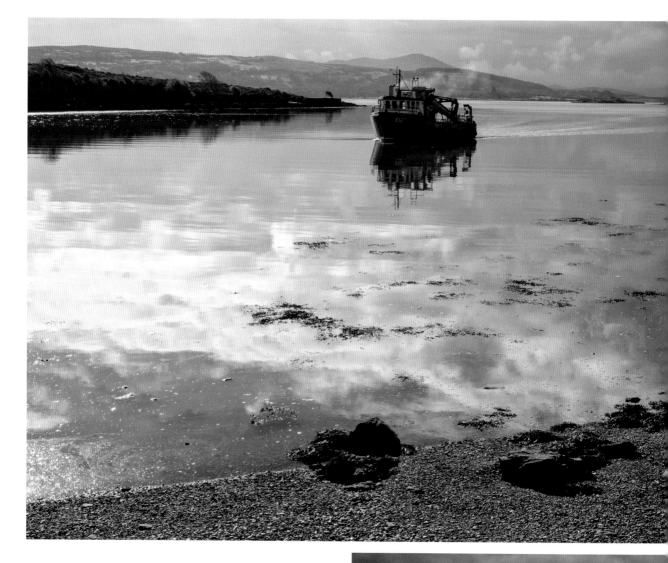

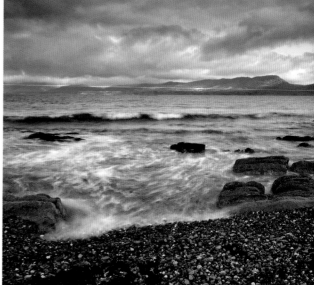

Left page top: Trawler returning to Carrickboy Pier, Sheep's Head
Peninsula, County Cork
Left page bottom: Hungry Hill from Sheep's Head Peninsula,
County Cork
Right page: Carrickboy Pier, Sheep's Head Peninsula, County Cork

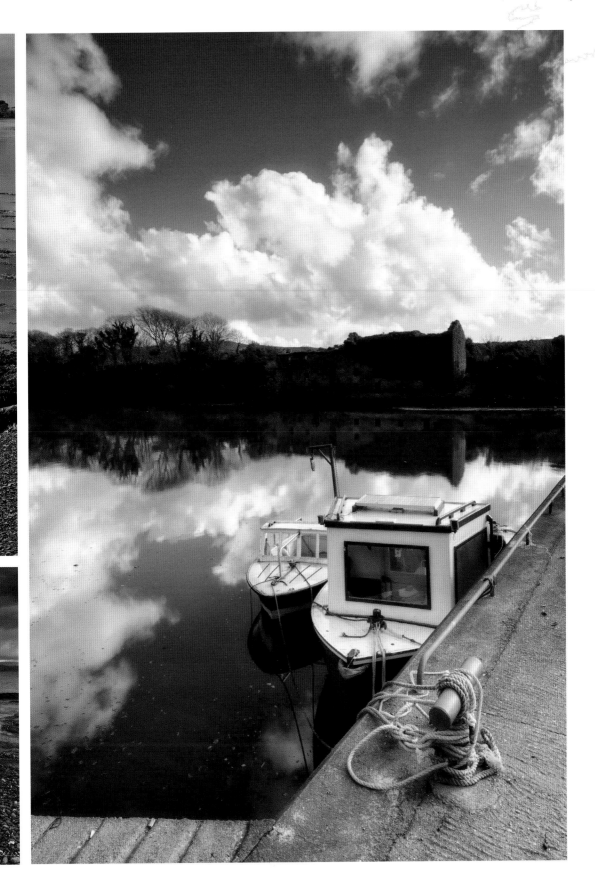

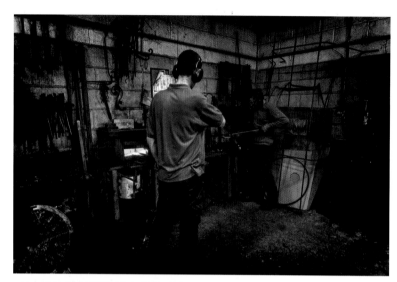

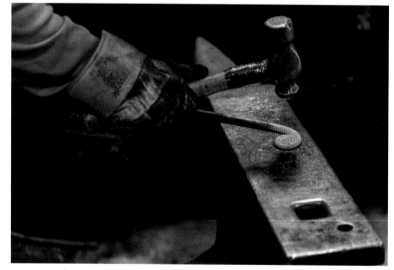

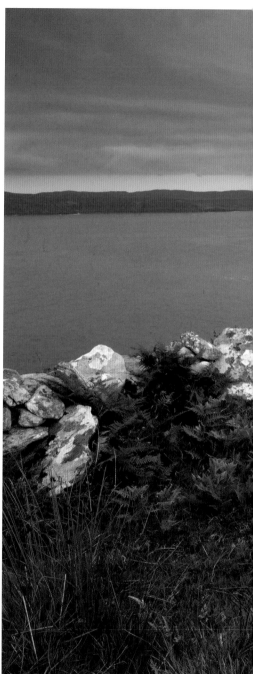

Left page top: Cronin's Forge, Durrus, Sheep's Head Peninsula, County Cork
Left page bottom: Kevin Cronin of Cronin's Forge, Durrus, Sheep's Head Peninsula, County Cork
Right page: Blue Dusk, Mizen Head from Sheep's Head, County Cork

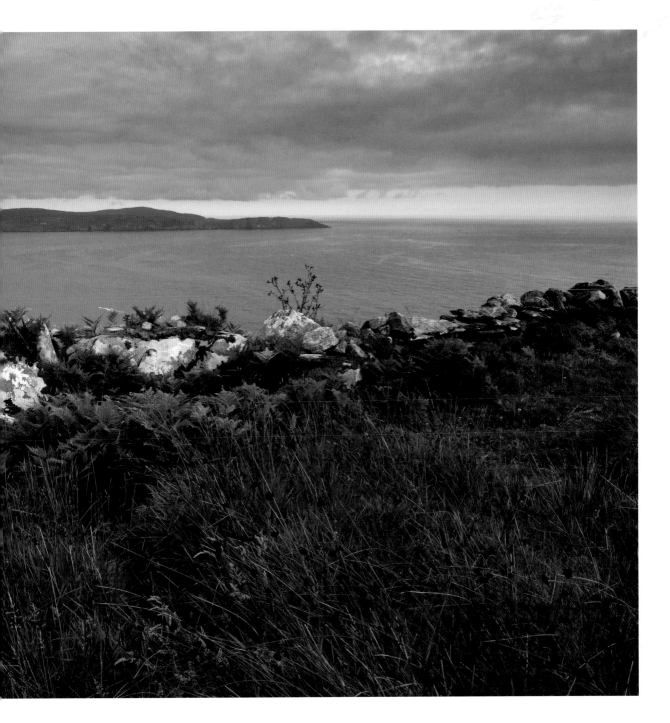

'There are the older siblings – the Iveragh and the Dingle peninsulas – well-known, heirs to the Kingdom, chocabloc with visitors. The Beara and Mizen peninsulas are the middle children, lesser spotted, steadily forging identities for themselves. Then there's the quiet kid: The Sheep's Head. It's barely twenty-five miles long and 2.5 miles wide, but don't let size fool you. It boasts one of the most spectacular walks in Europe.'

Pól Ó Conghaile, Travel Writer

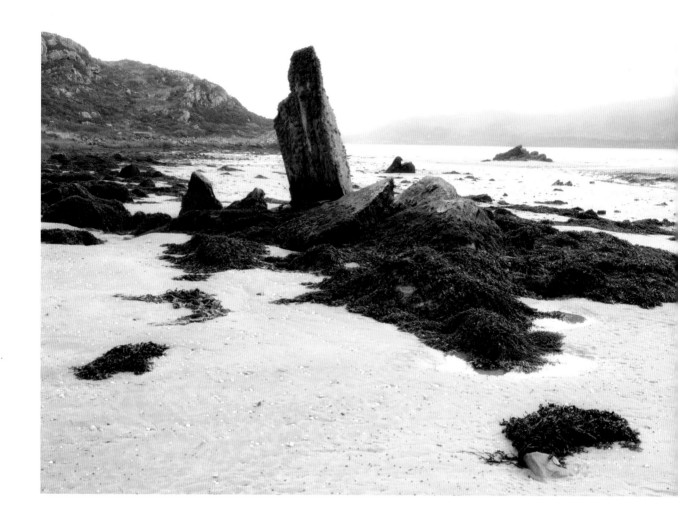

Left page: Crookhaven, Mizen Peninsula, County Cork
Right page top: Lough Akeen, Sheep's Head, County Cork
Right page bottom: Sheep's Head Lighthouse, County Cork

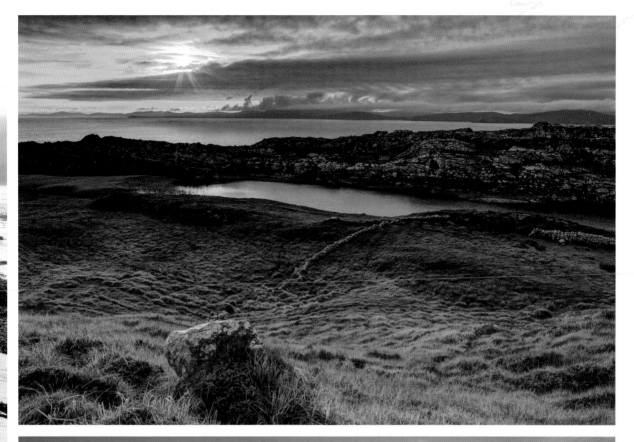

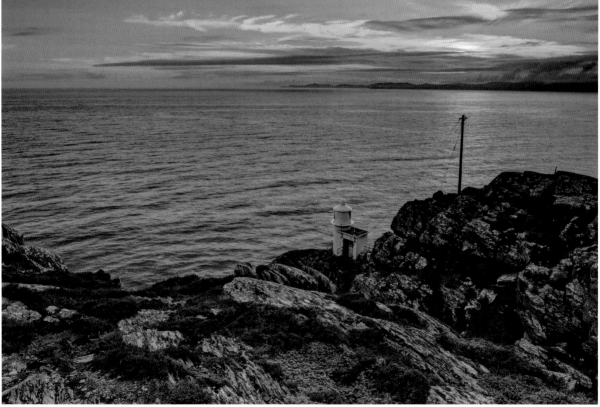

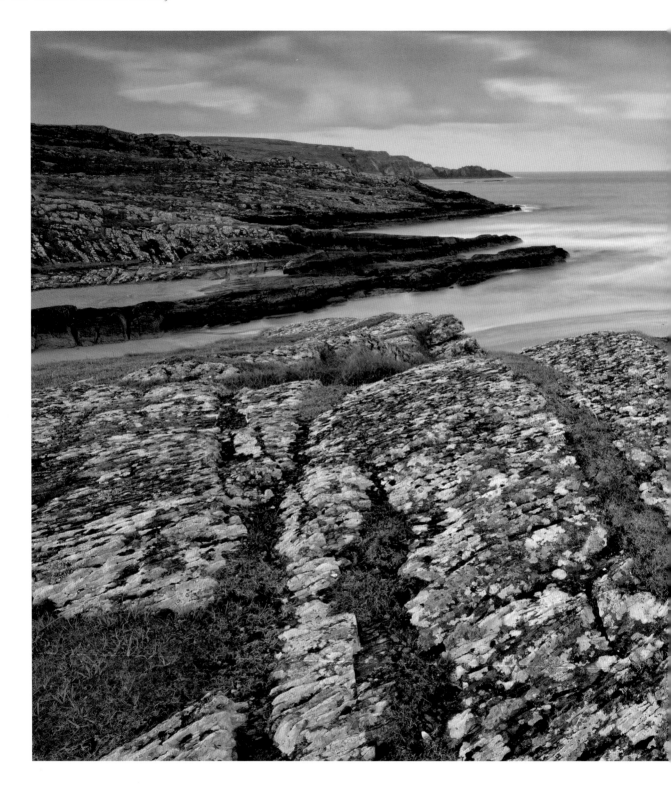

Left page: Barley Cove, Mizen Peninsula, County Cork
Right page top: Fastnet Sails Workshop, Goleen, County Cork
Right page bottom: Christophe Houdaille of Fastnet Sails, Goleen, County Cork

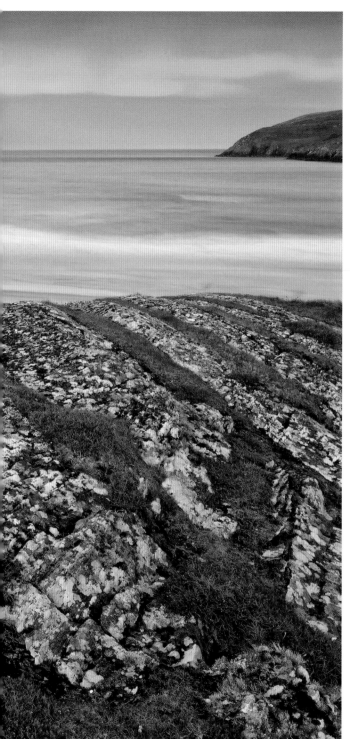

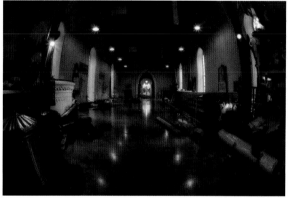

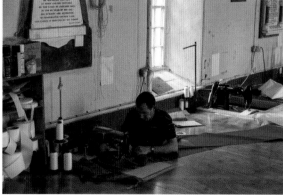

French native Christophe Houdaille is a sailor and sail maker with a most unusual office: An old Church of Ireland church. Apart from the removal of benches and other furnishings and the addition of sewing machines the interior of the church is unchanged; outside lays a typical overgrown Irish churchyard. It's a place with atmosphere. Unfortunately Christophe has given up his workshop since these images were made to go back to his native Brittany.

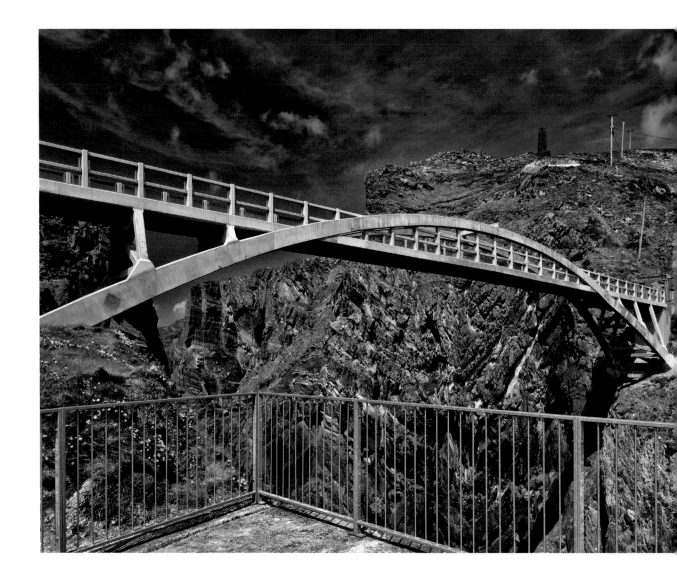

Left page: Mizen Head Bridge, Mizen Peninsula, County Cork. Mizen Head is Ireland's most south-westerly point.
The signal station is open to the public, and there is a Visitors' Centre and Maritime Museum on site.
Right page: Dunlough Bay, Mizen Peninsula, County Cork

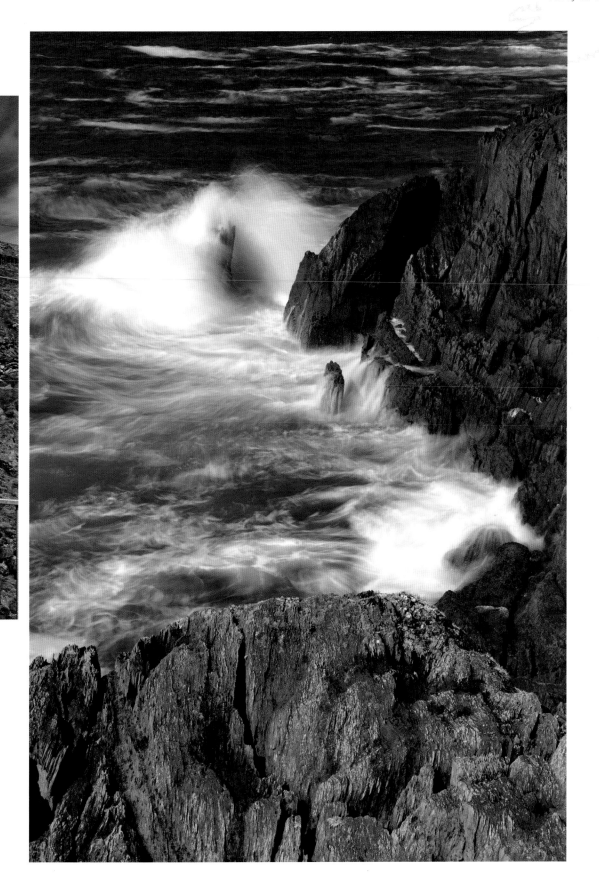

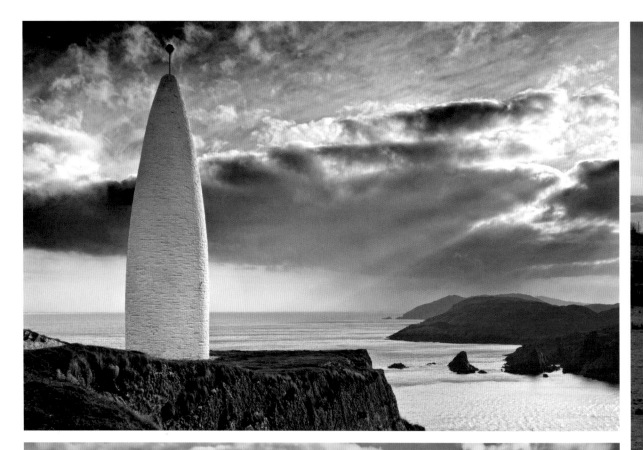

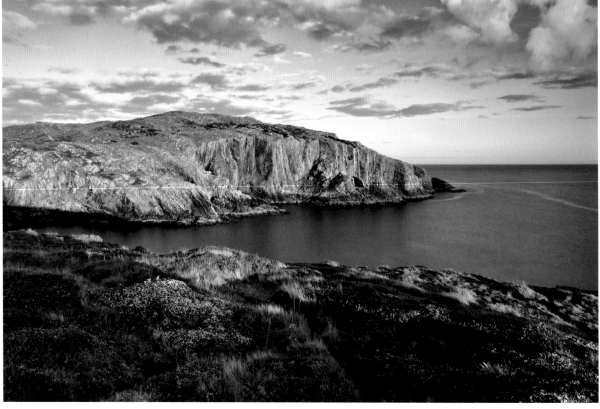

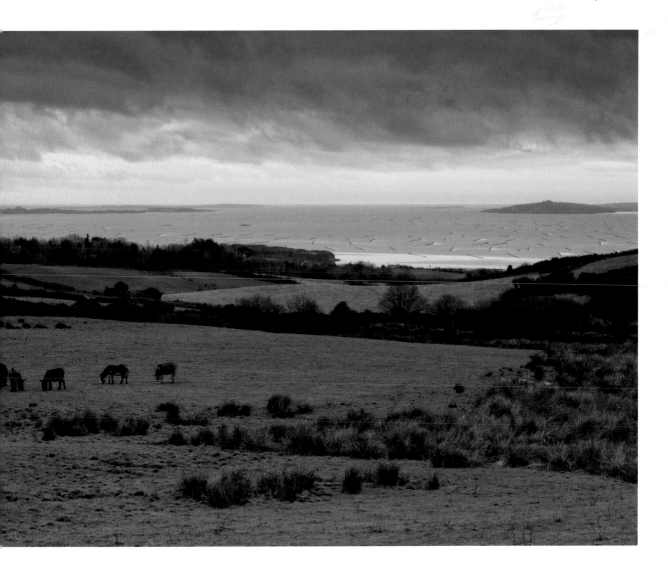

Left page top: Baltimore Beacon, County Cork
Left page bottom: Cliffs at Baltimore, County Cork
Right page: Roaringwater Bay, County Cork

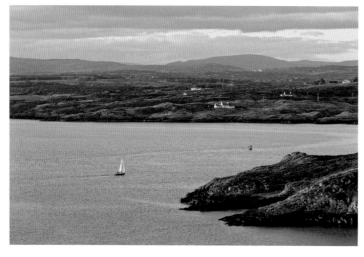

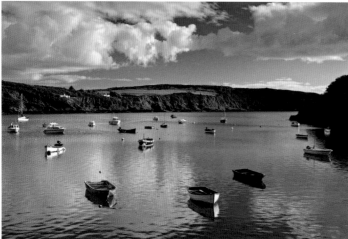

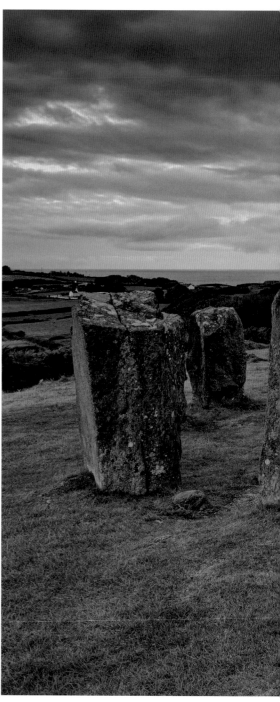

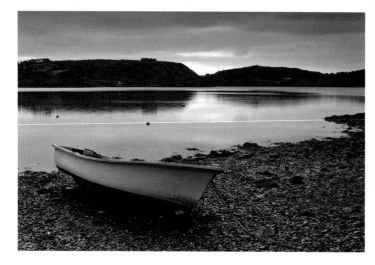

D rombeg Stone Circle is one of the most visited and most enchanting stone circles in Ireland. The seventeen stones, also known as the Druid's Altar, dominate the surrounding fields and hedgerows rolling down to the Irish Sea. According to radio-carbon dating the circle was in use from around 1100–800 BC, nearby huts and a *fulacht fiadh* (cooking place) were probably used up to the fifth century AD.

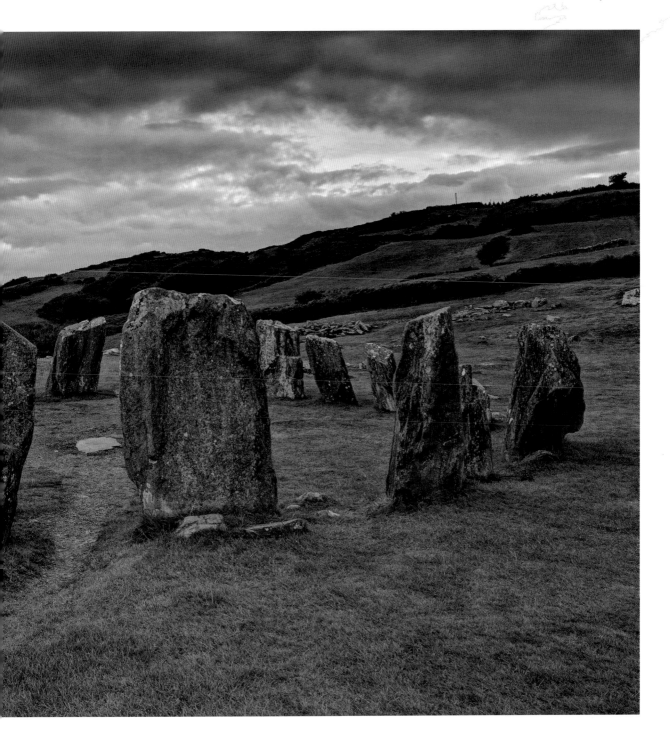

Left page top: Coming home to Baltimore Harbour, County Cork
Left page centre: Castle Haven, Castletownsend, County Cork
Left page bottom: Lough Hyne, County Cork. This marine lake was designated as Ireland's first Marine Nature Reserve in 1981; small and highly oxygenated, the lake is home to a wide variety of plants and animals.
Right page: Drombeg Stone Circle, County Cork

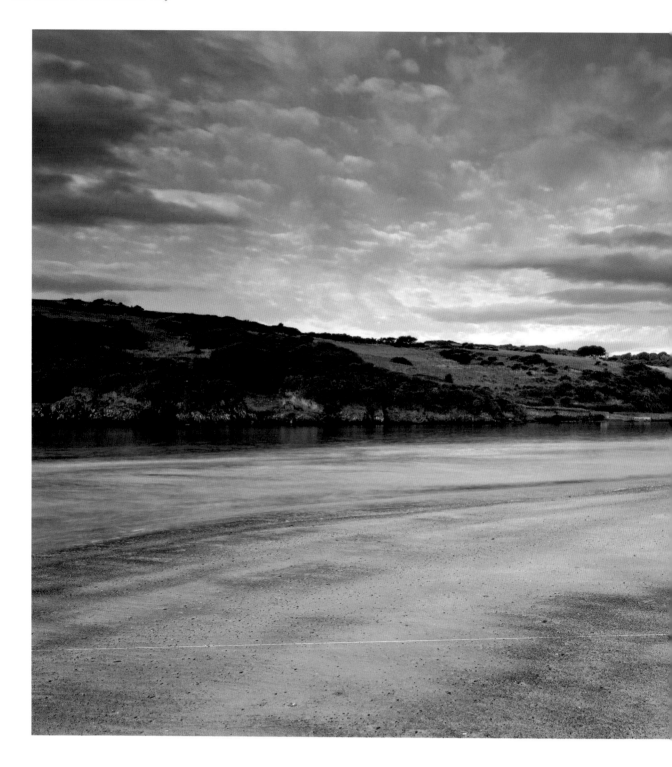

Left page: Summer morning at Warren Strand, Rosscarberry, County Cork
Right page top: Big surf at Warren Strand, Rosscarberry, County Cork
Right page bottom: Owenahincha Strand, County Cork

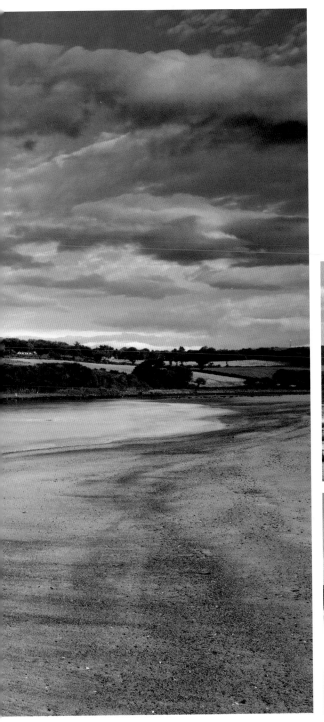

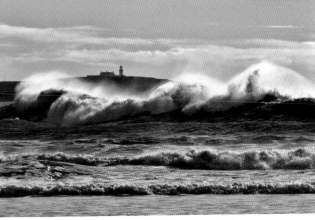

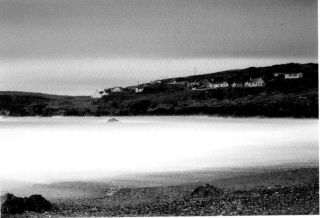

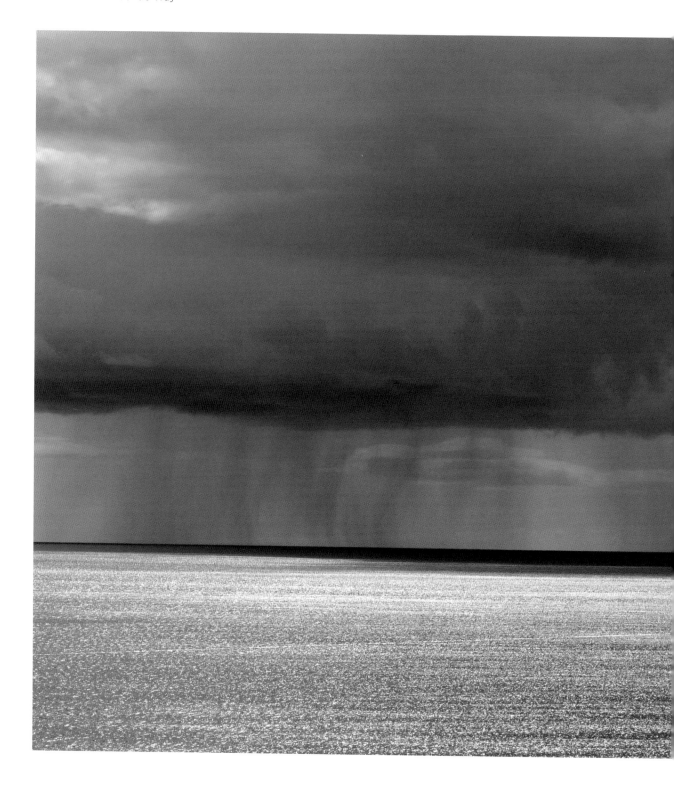

Left page: Rain on the water, Cloghna Head, County Cork
Right page: Galley Head Lighthouse, County Cork

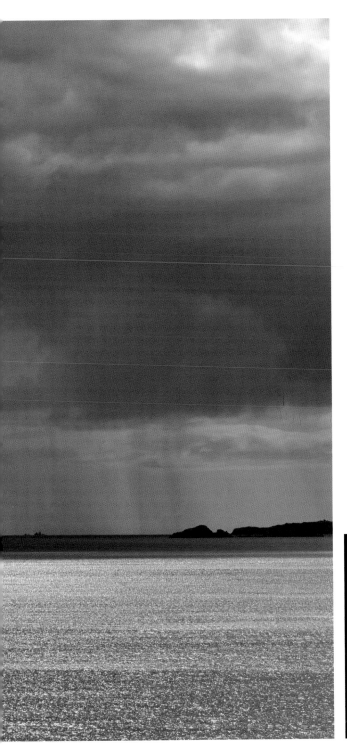

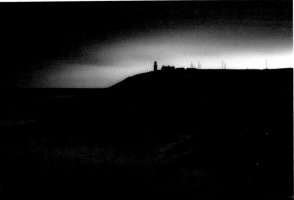

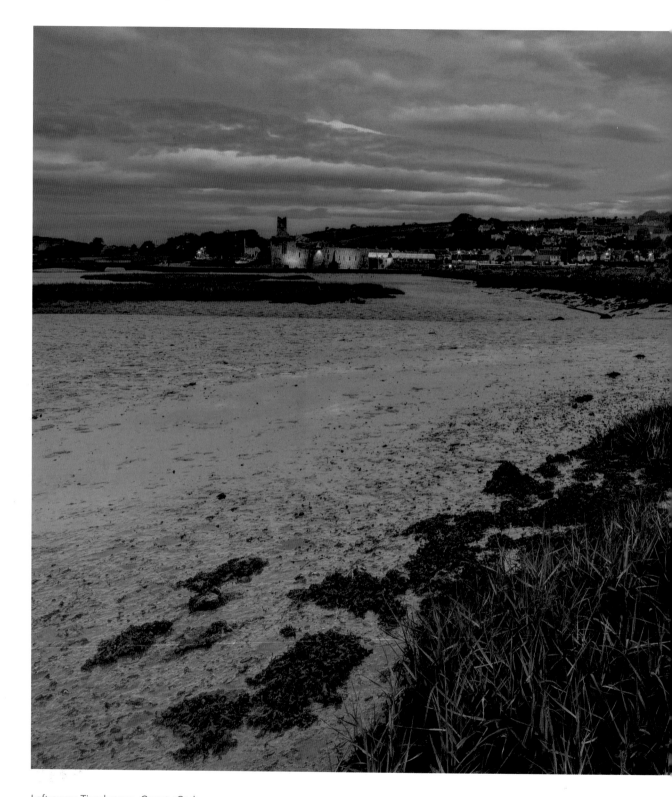

Left page: Timoleague, County Cork
Right page top: Timoleague Phone Box, County Cork. These phone boxes used to be a very common sight around the country until they were replaced first by more modern phone boxes and then became almost redundant with the advent of mobile phones.
Right page bottom: Michael Collins Statue, Clonakilty, County Cork

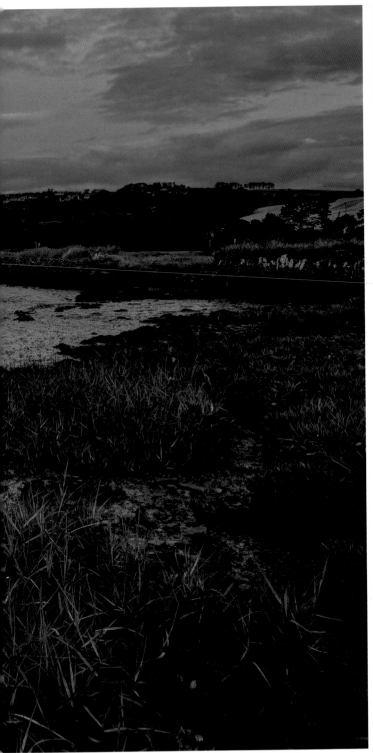

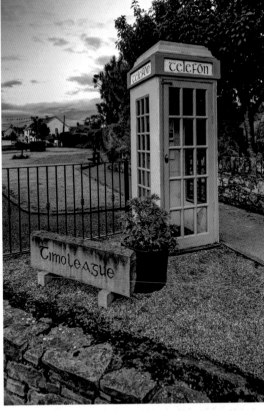

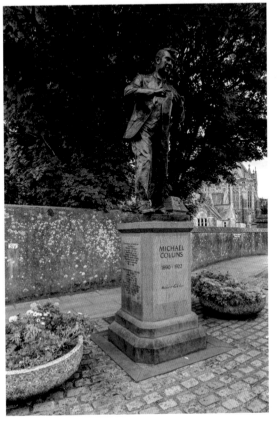

'Give us the future … we've had enough of your past …
give us back our country to live in … to grow in … to love.'
*Michael Collins, Irish Patriot,
Freedom Fighter, Politician and Martyr*

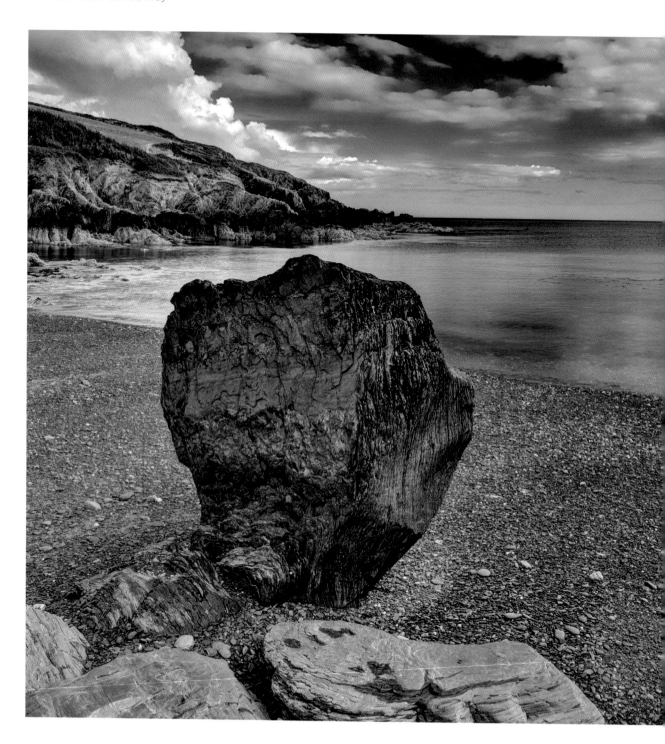

Left page: Sands Cove, County Cork
Right page top: Giles Norman, Photographer, Kinsale, County Cork
Right page centre: Cork Country Road near Red Strand, County Cork
Left page bottom: Old Head of Kinsale Golf Club, County Cork

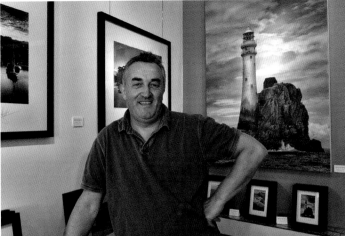

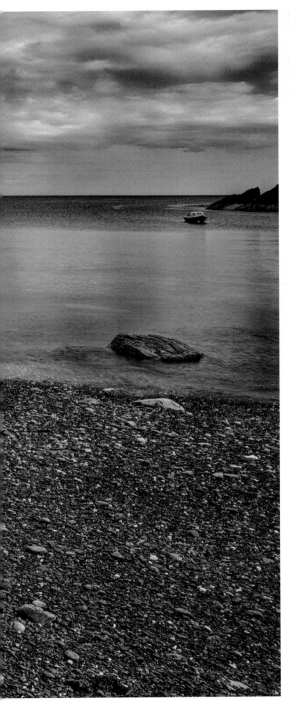

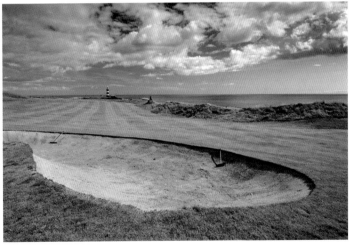

Y ou could call Giles Norman the godfather of black and white landscape photography in Ireland. He started his career in the early 1980s with a small darkroom in Kinsale and a small shop window that soon attracted a steady stream of visitors. The shop window was soon replaced by his first gallery which soon proved too small and in 1992 he moved into his current premises. His unique style and vision makes him without a doubt one of Ireland's most distinctive photographers.

First published 2015 by
The O'Brien Press Ltd,
12 Terenure Road East, Rathgar,
Dublin 6, Ireland.
Tel: +353 1 4923333; Fax: +353 1 4922777
E-mail: books@obrien.ie.
Website: www.obrien.ie
ISBN: 978-1-84717-696-7
Text & photography © copyright Carsten Krieger, 2015
Copyright for typesetting, layout, editing, design
© The O'Brien Press Ltd

Cover Design by Tanya M Ross www.elementinc.ie
Design and Layout by Tanya M Ross www.elementinc.ie

8 7 6 5 4 3 2 1
19 18 17 16 15

Printed and bound in Poland by Białostockie Zakłady Graficzne S.A.
The paper in this book is produced using pulp from managed forests

Text Credits:
In search of Ireland, HV Morton (Methuen, 1930)
Irisches Tagebuch, Heinrich Böll (DTV, 1957)
Footloose in the West of Ireland, Mike Harding (Penguin, 1996)
The Way that I Went, RL Praeger (Collins Press, 2014 (first published 1937))
Irish Shores, Paul Clements (Greystone Books, 1993)